Dedicated
to
Helene

THE AUTHOR desires to acknowledge his indebtedness to Dr. Ernest E. Tucker as his collaborator in the preparation of this volume. G. B. B.

THE BOOK OF
A HUNDRED HANDS

THE BOOK OF
A HUNDRED HANDS

GEORGE B. BRIDGMAN

DOVER PUBLICATIONS, INC.

Garden City, New York

This Dover edition, first published in 1971, is an unabridged and unaltered republication of the work originally published by Edward C. Bridgman in 1920. It is reprinted by special arrangement with Sterling Publishing Company, 419 Park Avenue South, New York City 10016.

Library of Congress Catalog Card Number: 78-182099

International Standard Book Number
ISBN-13: 978-0-486-22709-2
ISBN-10: 0-486-22709-X

Manufactured in the United States by LSC Communications
22709X31 2020
www.doverpublications.com

Introduction

❖

Helvétius, in 1758, in an essay on "The Mind," quoted by H. T. Buckle in his "Introduction to the History of Civilization," maintains as an incontrovertible fact that the difference between man and animal is a result of the difference in their external form; that if for example the wrists instead of ending in hands with flexible fingers had ended like a horse's hoof, man would have remained a wanderer on the face of the earth among the animals, ignorant of every art and entirely defenseless; that this structure—the hand—is the sole cause of our superiority.

Ever since the genesis of the human race, the hand has been the indispensible instrument of its continued advance. About the creations of this hand, in science and in art, an endless succession of volumes has been written; to the hand, also, many scientific works are devoted; but the writer has not discovered a single volume devoted exclusively to the depicting of the hand.

It is the purpose of this work to present the hand not only to the eye, but to the understanding.

History of the Hand in Art

❧

Nature standardizes all hands to laws of mechanics and dynamics. The hands of the mummies of ancient Egypt, thousands of years old, are not different from those of today. The bones of prehistoric man are the same. Ninety per cent., and more, of the hand is standardized by its use to the unchanging laws of its use.

But the hand as drawn and sculptured has varied markedly in different ages. Cave dwellers marked the walls and roofs of their dwellings and their implements with signs and figures, and among them, hands. The hands they drew or carved had a general character distinctly of that age.

The Peruvian, the Aztec, the American Indian in his written sign language, the Alaskan on his totem pole, each of these—whether the hand was carved out or cut in, drawn or painted, in red or blue, wherever a hand was shown—adhered to a certain style of hand whose character marked it as belonging to that age or that tribe or that race, and all distinctly different from other periods or races or tribes.

The Assyrians graved hands on their palace walls and carved them in stone; and they were Assyrian hands, distinguishable easily from those of any other race or age. The Egyptians told stories by means of carved and painted hands, as individual as those of any other place or time.

When we come to the ages of a more studied art, the same psychological law is in evidence. There is an early Gothic hand, distinctly different from that of any other period.

There is a Renaissance hand with a character of its own; so much so that they can be picked out and classified, not only as Renaissance hands, but as early or late Renaissance hands.

No one questions the sincerity of Ghirlandajo, or of Lippi, or of Botticelli. Not only were they great masters, but close students, and yet each drew a different style of hand.

Of later schools the same thing may be said; as of the Venetian and the Dutch schools, and of the schools of Jordaens, Rubens and Van Dyck. Of Van Dyck it has been said that he could not draw the hand of a laborer, and of Millet that he could not draw a gentleman's hand.

Indeed, it is very far from accurate to say that we see with our eyes. The eye is blind but for the idea behind the eye. It is the idea behind the eye that makes it different from a photographic plate— that pricks out some parts with emphasis and censors other parts. We see with the idea, and only *through* the eye.

Michael Angelo, Leonardo Da Vinci and Raphael, all of the same period, all had the same style of models, and yet they produced hands of three very distinct types.

Albert Dürer, Holbein the younger, Rembrandt, all made hands that, because of their individuality, are classed as a Holbein or a Dürer or a Rembrandt hand by the art world.

Reasons for this change and flux in character and style of hands are no doubt familiar to every one. Briefly, the hand as pictured is not subject to the automatic forces that standardize the actual hand to the laws of its use. The pictured hand is standardized to no laws except those of perception; which means to the current concepts and to indi-

vidual taste. The business of the artist in such a connection is to standardize his concepts of the hand to those of nature—to see it as nature sees its purpose, methods, laws.

It may be reflected that the science of anatomy is a comparatively recent acquisition of the race. It is not many decades since the cutting up of the human body was forbidden by law and abhorred in religion. Even after such a study is well developed, it takes a certain time for its significance to penetrate to other domains of thought and effort, and a much longer time for it to be assimilated there.

It has taken man centuries to learn to look under the form for the mechanisms in the human body; and he is only now learning to look under the mechanisms for the reasons that underlie them. The world of art is beginning to appropriate these things to itself, and the improvement in one man's technic by this means compels others to seek improvement in the same school—the school of nature, her reasons and her purposes.

If this tendency to fluctuations, to styles and fashions is more marked in the hand than in other parts of the body, it is probably because the importance of the hand as an avenue of expression has not been understood. The hand is thought of as the slave of action. But the slave of action is the master of expression.

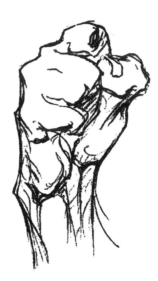

Expression

❖

The face is well schooled to self-control as a rule, and may become an aid in dissimulation of thought and feeling.

Rarely is the hand so trained; and responding unconsciously to the mental states, it may reveal what the face would conceal.

Like any other living thing, the hand is modified to its use. The total modification in any individual is less than one per cent.; but in a succession of generations it may be cumulative. Also it happens that it is the more superficial and conspicuous parts that are thus modified.

On the background of the mechanics, then, which is older than the human race, we may have racial variations; then on this basis, accumulated hereditary or family modifications, and on them in turn expressions of individual history and character.

The hand of the child is almost unmodified. With its creases and dimples and its tapering fingers, it represents almost the pure symmetry that is the natural heritage of all created things.

The hand of age represents the opposite extreme, the end product, the insanity of over-modification; furrowed, wrinkled with the scars of time, with enlarged squared joints, and shaky.

On the background then of mechanics and racial variations, we have many variations, such as those of youth or age; male or female; healthy or unsound; laboring or aristocratic; strong or weak.

Types of hands may be classified as: square, round, compact; long or short; thick or thin. The relative length of fingers varies, both among them-

selves and in comparison with the hand. The relative thickness of joint and shaft and finger tip varies. The thumb may be short, thick or thin, may lie close or spread far from the hand.

The hand that is inured to heavy labor shows very definite changes. It is larger and heavier. The muscles are of course developed, but these lie for the most part above the hand in the forearm. Those of the thenar and hypothenar eminences are somewhat larger and more square. Chiefly, the joints become enlarged, square and rugged and irregular in appearance. The tendons are more in evidence. The skin is hardened, so that creases are deeper; especially are the skin pads heavier and may overhang the borders. The skin hairs may stand up like bristles. In repose it assumes a more crooked position. Clenched, with the aggressive thumb twisted around the fingers, it becomes a squared, knobbed and formidable looking weapon.

The converse of this is true in the hand not inured to labor. The muscles of the palm present a softly rounded appearance, the skin is smooth and silky, the skin pads not clearly demarked; the joints are not only not rugged, but may be unduly flexible, small and weakly angled. The bones of the hand and fingers will have less of the spring curve, that is, will be straighter, and slighter. The hand will on the whole be much more symmetrical and expressionless.

When the hand is employed in what may by contrast be called the intelligent uses, in which flexibility is necessary, it will have as a consequence greater freedom of movement, will assume much more varied positions, and will express much more readily the mental states. In proportion as this

habitual exercise is free and intelligent, will the symmetries assumed be free and expressive.

Certain typical positions are due not so much to the mental states as to the mechanics of the hand. For instance, the little finger side is always more flexible than the thumb side, because it is opposite to the powerful thumb. The middle finger is always inclined to bend farther forward, or to bend forward first; this on account of its relatively greater power. All fingers bend forward first at the knuckles, then at each joint in turn. The thumb is habitually carried somewhat extended, out of the way of the fingers.

Modern psychology, studying the dynamics of the nervous system, informs us in regard to many of the instinctive positions and actions of the body (including the hand) and the things expressed by them. For instance, there is a wholly involuntary opening out movement of the whole body, limbs and features, in pleasant emotions, honesty, courage, understanding, etc.; and conversely, there is a closing up, a drawing in, a turning away, in unpleasant emotions, in mental dishonesty, etc.

In states of self-consciousness, and the effort at self-control, there is a tendency to express the same by clasping one's self; as clasping the thumb with the fingers; clasping or twisting the other hand, or some part of the body.

THE HAND
Back View

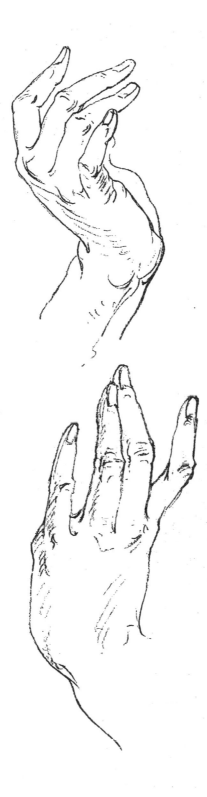

THE HAND

BACK VIEW

The wrist bones are collectively smaller than the end of the forearm, so there is a constriction at the sides.

The wrist bones are in two transverse layers with an angle between, forming in profile view a hook, point backward (mechanisms, page 159); over which is a step-down to the back of the hand. A little to the outer side, this is bridged by the extensor tendons.

The rows of wrist bones are arched toward the back. The two pillars of this arch in front far overhang the anterior line of the arm (pages 33, 39, 163). From them arise the thenar and hypothenar eminences, and the palm of the hand.

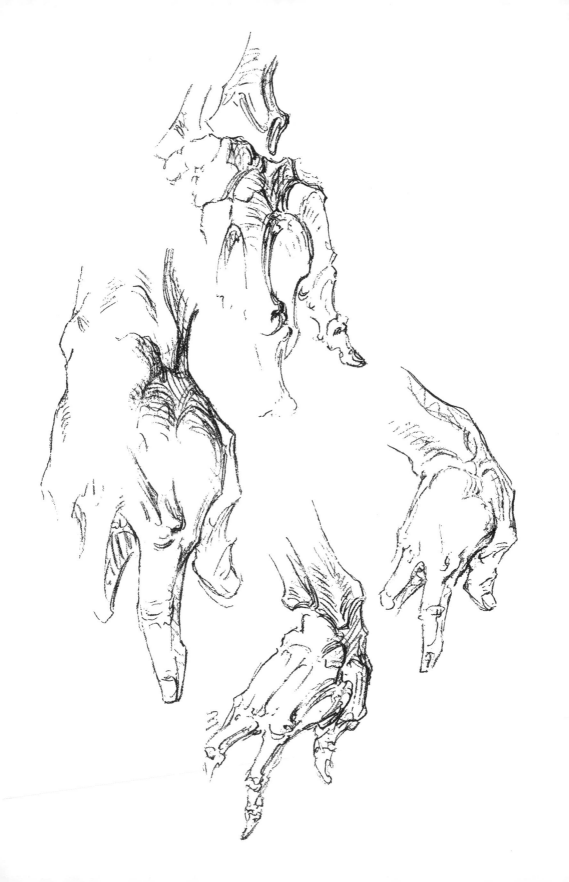

THE HAND

Except for the thumb and the extensor tendons, the back of the hand is smooth. It is slightly arched from side to side.

It is beveled from knuckles to wrist, and is narrower on the back than on the palmar surface. There is a slight fan-like movement among the bones of the hand.

The general mass of the back flows from the wrist toward the first and second knuckles, and is flattened and thinned toward the little finger side.

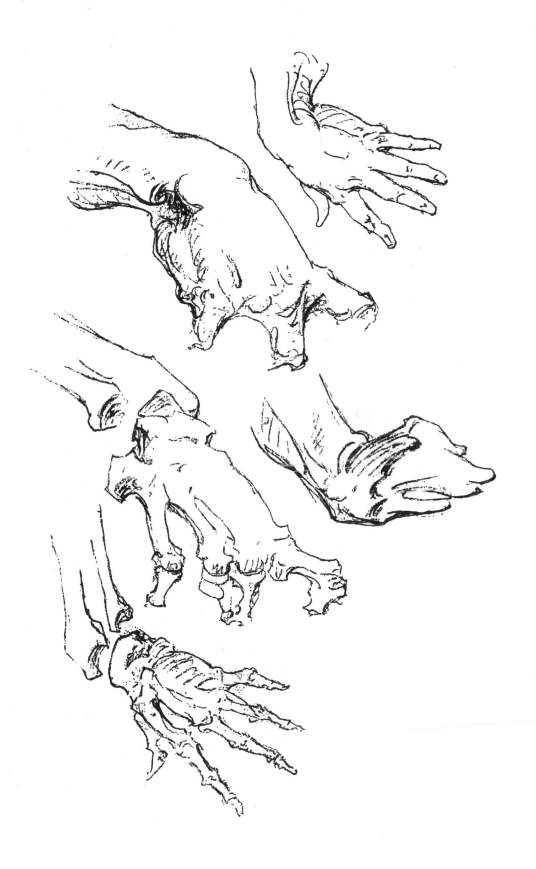

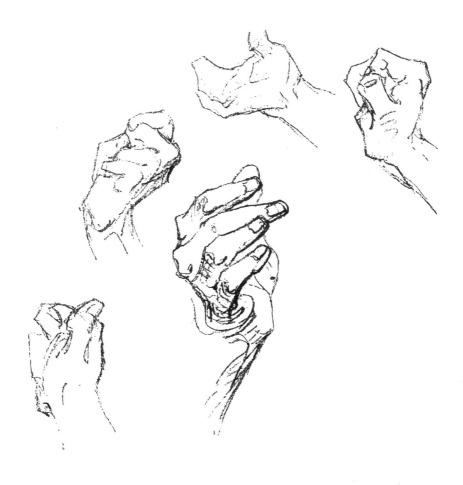

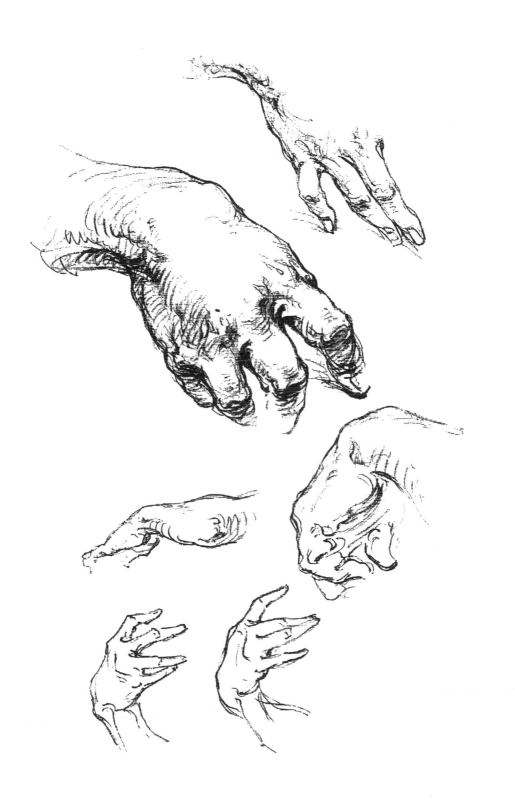

THE HAND

Distributed over the back are seen the extensor tendons. These represent two sets which have become blended, so have duplications and various connecting bands. Those to the thumb and little finger remain separate.

1 Extensor communis digitorum.

2 Abductor minimi digiti.

3 Dorsal interosseous.

4 Adductor pollicis.

5 Extensor carpi ulnaris.

6 Extensor minimi digiti.

7 Extensor longus pollicis.

8 Extensor brevis pollicis.

9 Extensor ossis metacarpi pollicis.

ORIGIN, INSERTION AND ACTION
OF MUSCLES
Page 169

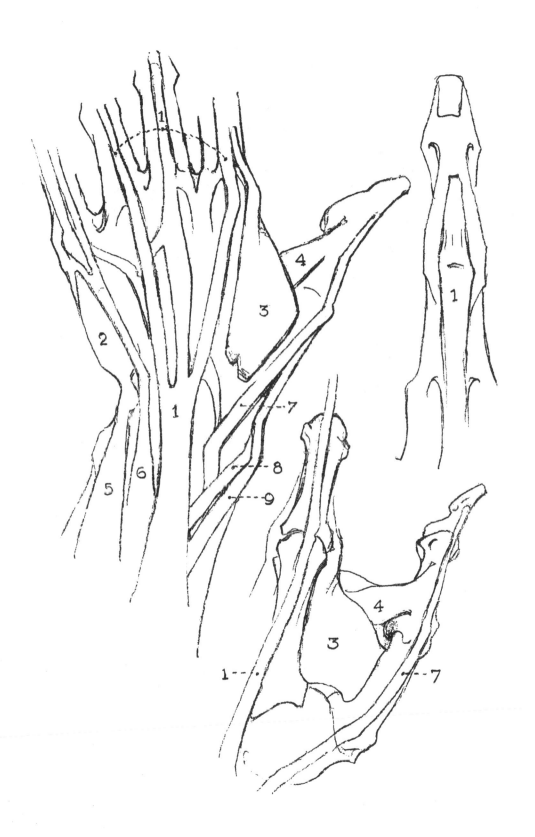

THE HAND

BACK VIEW

Unlike those of the front, the tendons on the back of the hand pass quite high over the wrist. It is clearly impossible to arch the wrist both ways; and flexion being so much more important a function, the extensor tendons are forced far from the centre of movement backward and outward. They converge on the low outer part of the wrist arch. Thus placed they are taut in extreme flexion, so that the fingers cannot be tightly closed.

The thumb side of the wrist arch is larger, higher and projects farther forward, carrying the thumb; it has a deeper inset at the wrist and is square compared with the heel inside, which ends in a ball—the pisiform bone.

On the little finger side of the wrist, between the end of the ulna and the pisiform bone, may be seen a "rocker"—the cuneiform bone.

This is the part of the arch of the wrist immediately above the pisiform—its outer end. It is prominent when the hand is bent to the opposite side or in the act of pulling. It almost blends with the ulna when the hand is carried to that side.

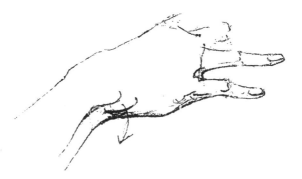

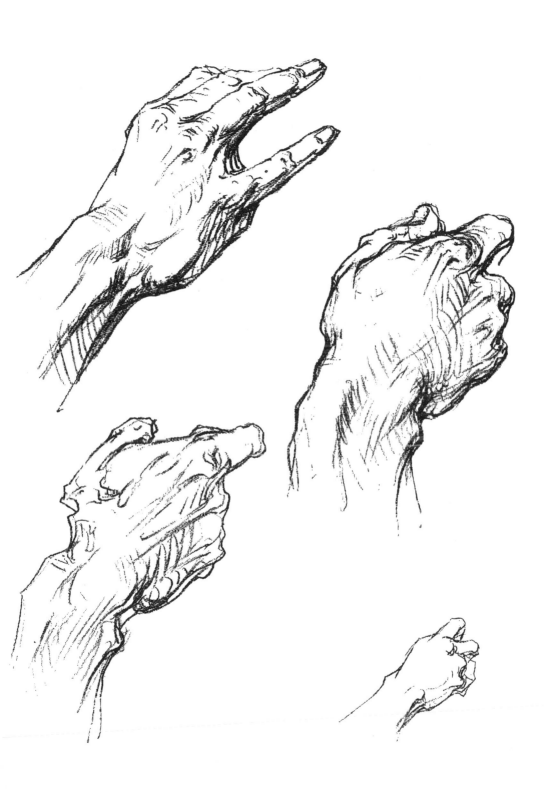

THE HAND

To the four corners of the wrist are fastened four muscles, one of them doubled (that on the back of the first finger side).

BACK VIEW

1 Extensor carpi ulnaris.

2 Extensor communis digitorum.

3 Extensor ossis metacarpi pollicis.

4 Extensor brevis pollicis.

5 Extensor carpi radialis brevior.

6 Extensor carpi radialis longior.

ORIGIN, INSERTION AND ACTION
OF MUSCLES
Page 169

PALMAR VIEW

7 Supinator longus.

8 Flexor carpi radialis.

9 Tendon of the palmaris longus.

10 Flexor carpi ulnaris.

11 Palmar fascia.

ORIGIN, INSERTION AND ACTION
OF MUSCLES
Page 171

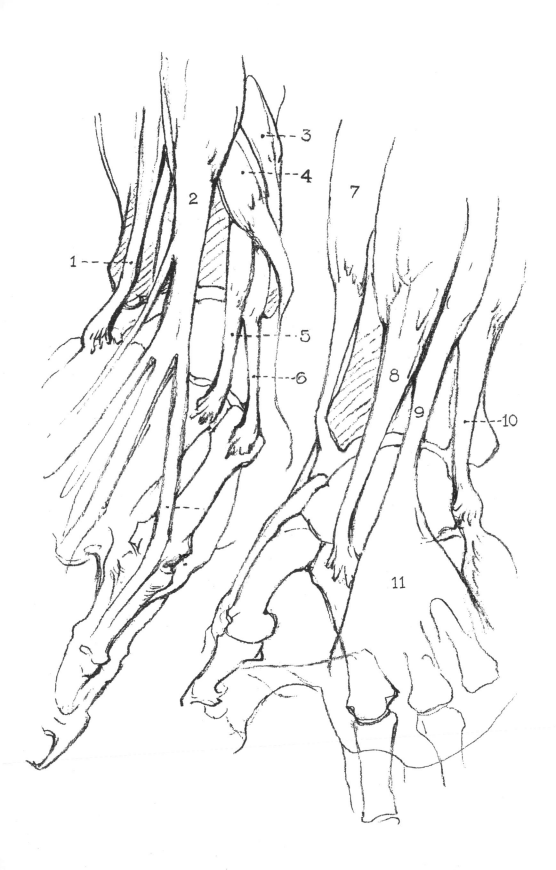

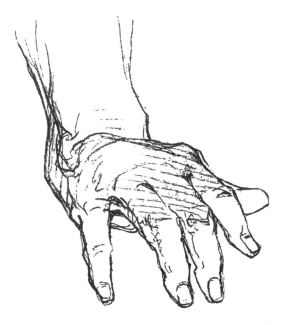

THE HAND
Back View

Morticed with the bones of the wrist, and moving solidly with them, are the four bones of the hand, one for each finger. Each bone is slightly arched forward, as every bone in the body is slightly arched; they have a shaft with enlargements at each end, also as every other bone in the body. These enlargements are for two reasons—first, safety, on account of exposure and strain at the ends, and second, to afford space for joint surface and for attachment of ligaments and muscles.

Their enlarged ends are in contact with each other not only at the wrist, where they are almost solid, but also at the knuckles, where is some slight fan-like movement, freest in the little finger.

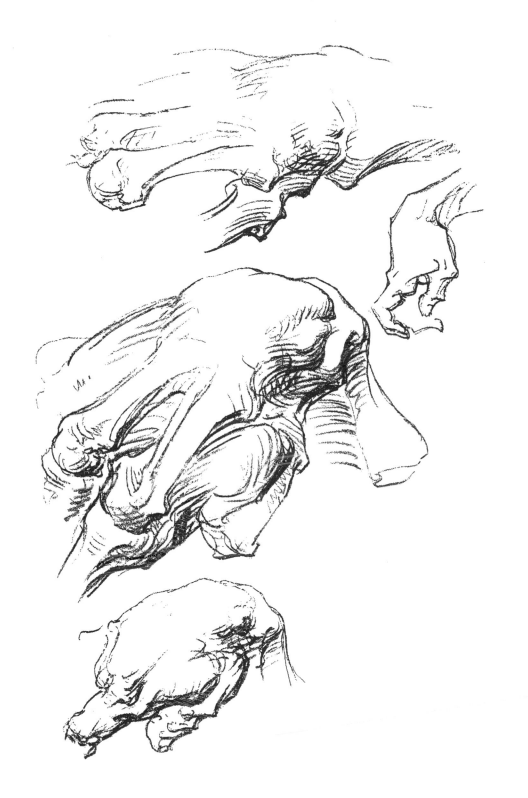

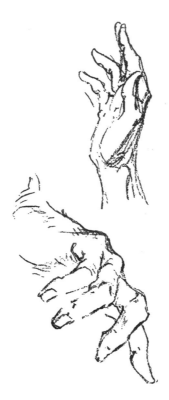

THE HAND

Back View

The hand is arched backward from side to side, being highest at the second finger.

The arch reaches from the metacarpal bone of the first finger to that of the little finger.

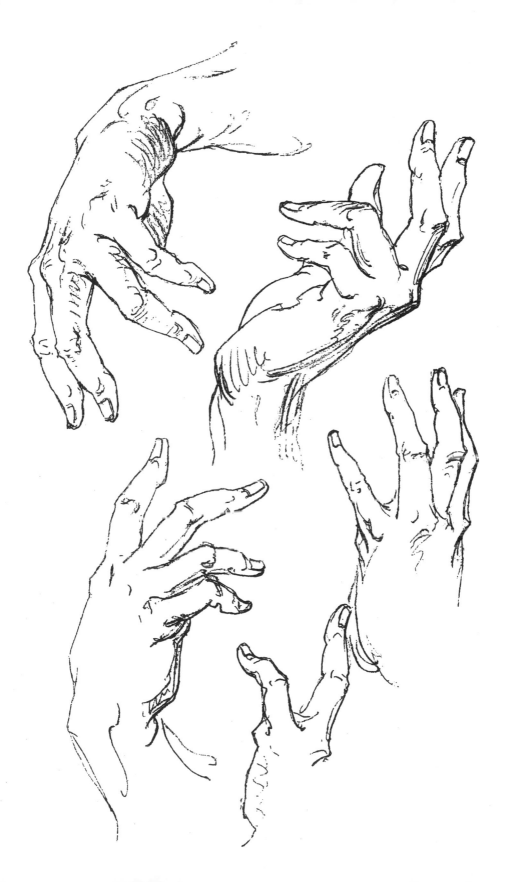

THE HAND

From the bone of the first finger the mass sets sharply forward toward the thumb.

From the bones of the little finger also it sets sharply forward, forming the back of the hypothenar eminence.

The back of the hand is marked by the prominence of the first two metacarpals at the wrist, by superficial tendons converging on the wrist, often covered with heavy veins, and by the knuckles.

Somewhat raised above the level of the back are the knuckles. They are in a curved line, concave around the base of the thumb; i. e., palmward and wristward. When the fingers are extended, creases form between the knuckles following different directions. These diverge from the middle knuckle, curving over the first and third, while that from between the third and fourth curves over the fourth.

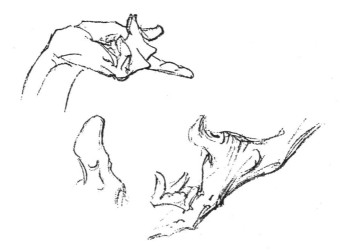

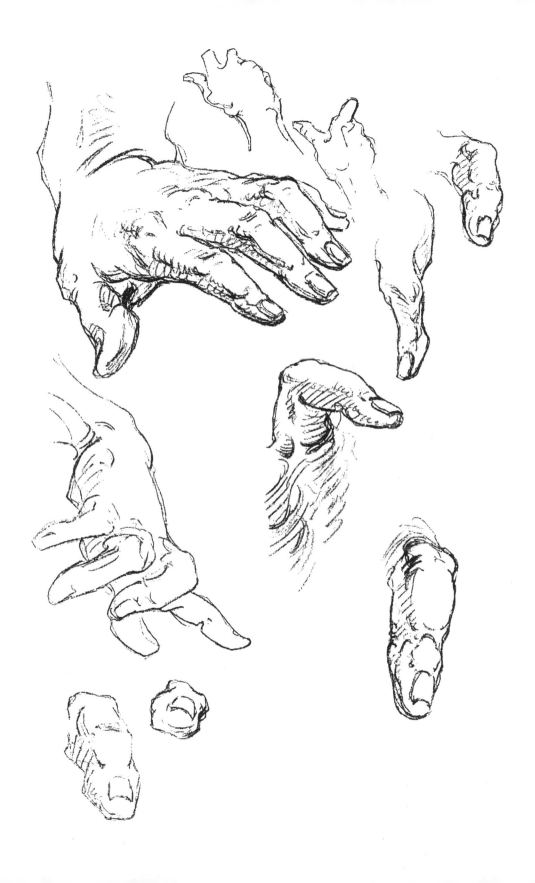

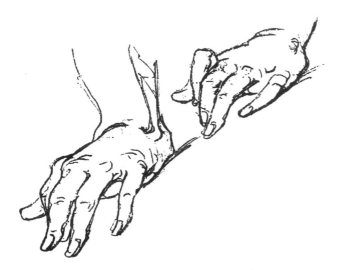

THE HAND

BACK VIEW

With the palm resting on the table, the weight is carried normally by the little finger side (pisiform bone or heel of the hand). Opposite it is the hook of the unciform. Between them the tendon of the palmaris longus bulges the wrist.

The weight on the thumb side is carried not by the wrist pillar (unciform bone), but by the muscular mass (thenar eminence). The thumb naturally lies on its side, but may by pressure be flattened toward the table.

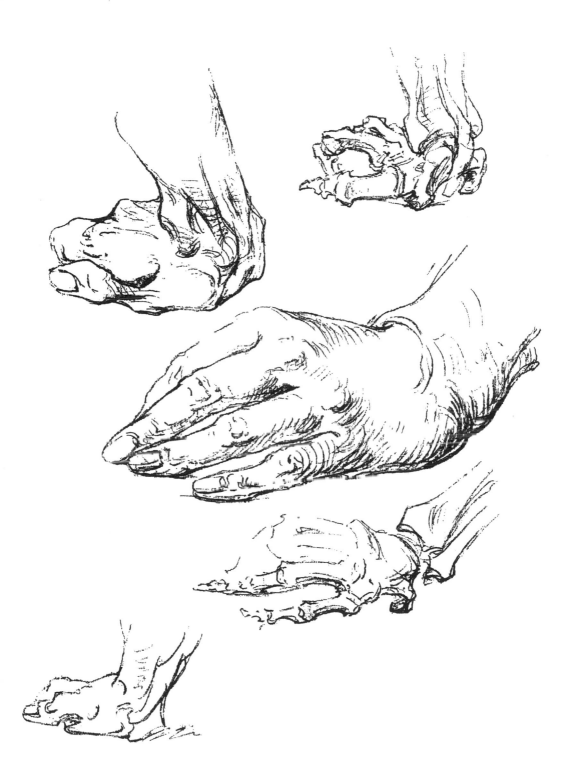

VEINS

Enlarged veins have in reality nothing to do with muscular development or rough usage, but are due to conditions of health or ill health. Their size, location and elevation are extremely variable. The same thing is true of the skin hairs, although these are more likely to be erect and therefore conspicuous in the hands roughened by labor.

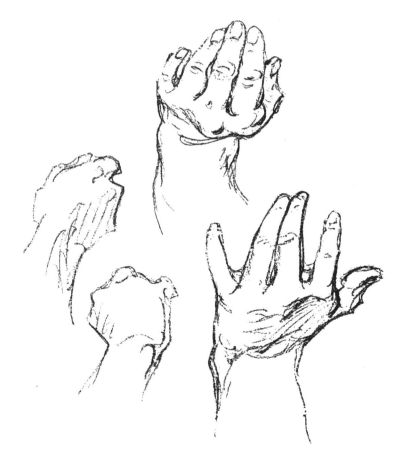

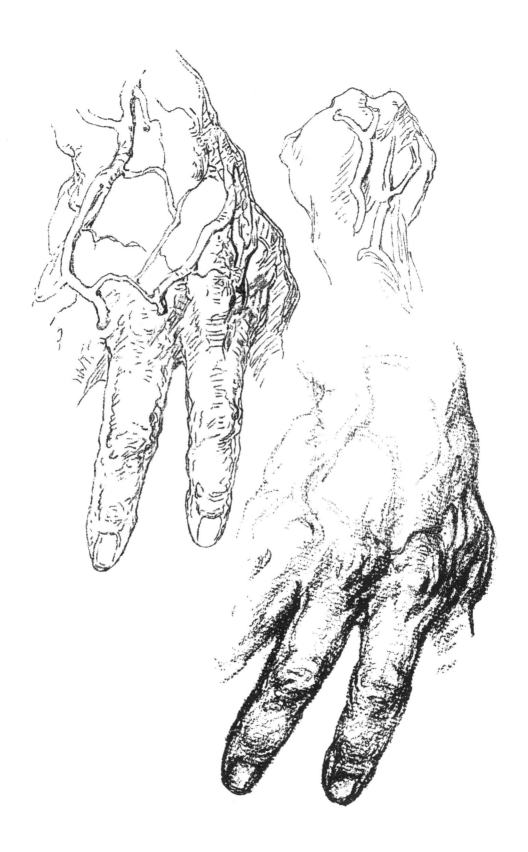

THE HAND

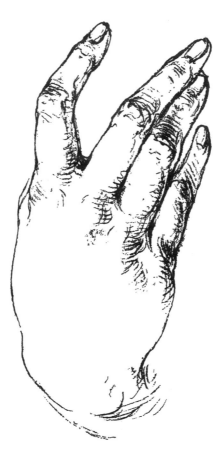

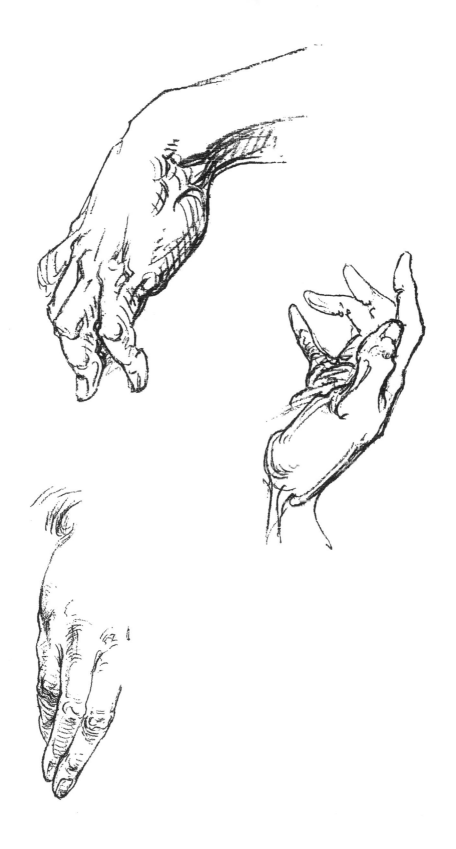

THE HAND
BACK VIEW

1 Abductor minimi digiti.

2 Tendons of extensor
 communis digitorum.

3 First dorsal interossei.

ORIGIN, INSERTION AND ACTION
OF MUSCLES
Page 169

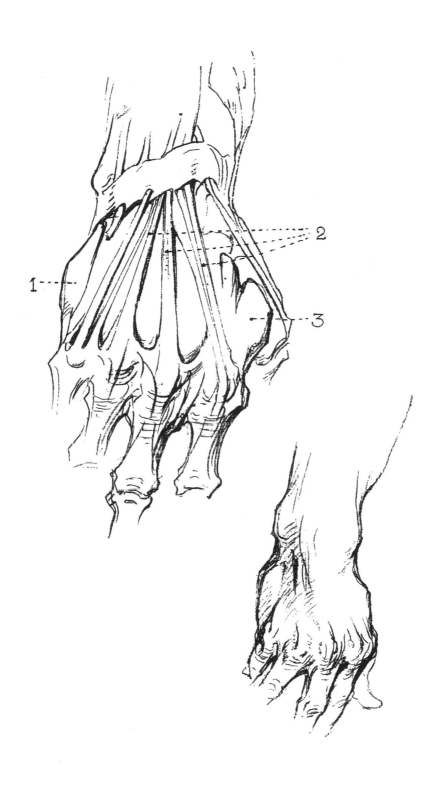

THE HAND
Palmar View

THE HAND

PALMAR VIEW

The palm slightly overlies the wrist, and extends to the middle of the first joint of the fingers. It is made of three portions, with the hollow of the palm between them.

On the thumb side is the largest of these portions, the thenar eminence; opposite it is the hypothenar eminence, and across under the knuckles is the third portion, the mounds of the palm.

The thenar eminence is high, fat and soft; it contains the short muscles of the thumb and forms with the bone the pyramidal first segment of it.

The hypothenar eminence is longer, lower, harder and more triangular. It contains some muscles of the little finger, large on account of the exposed position of that digit, and part of the palmaris brevis. It reaches as far as the base of the little finger, blending there with the row of mounds. At the wrist it covers the pisiform bone, with a heavy fibrous pad like that of the heel.

[48]

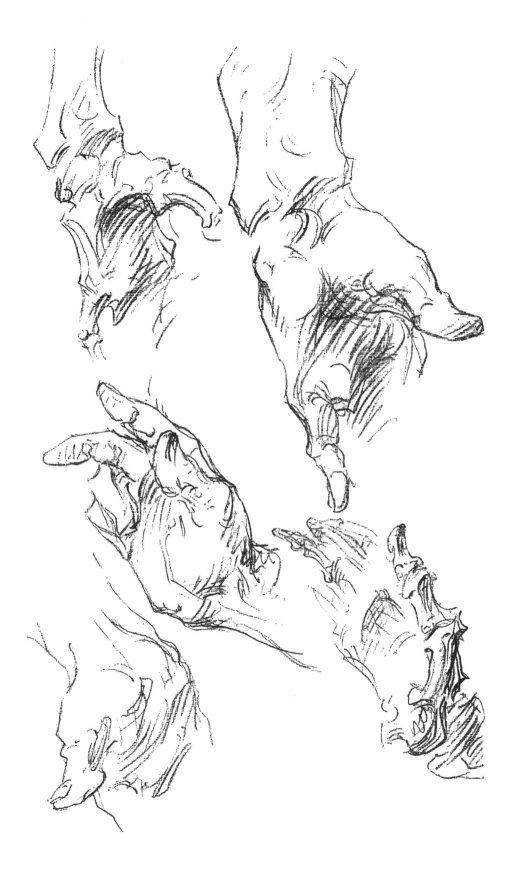

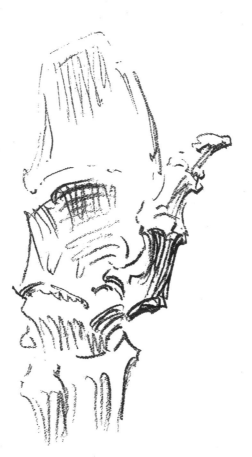

The bones as a group form a mass that is beveled from wrist to fingers, and from thumb to little finger side, in profile; and in palmar or dorsal view, from knuckles to wrist. The mass is slightly concave forward, following the curve of the wrist.

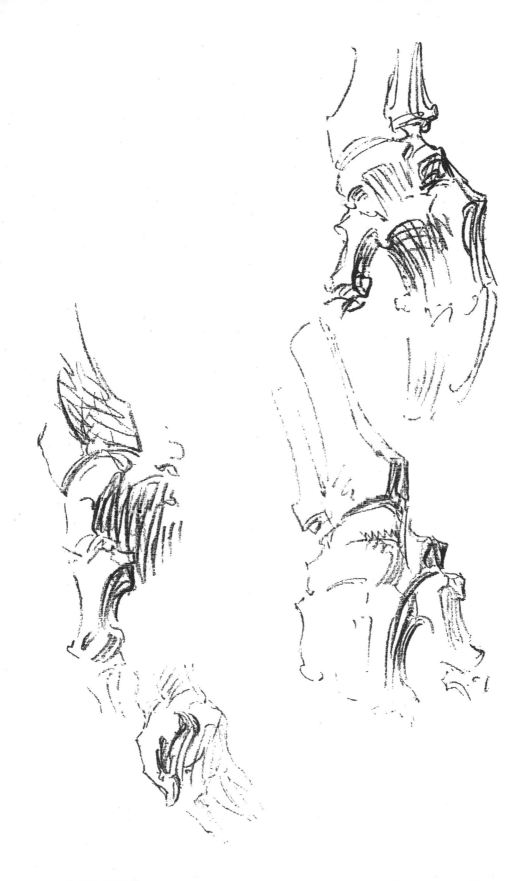

THE HAND

1 The hypothenar eminence, composed of the ab-
 ductor, flexor and opponens muscles of the
 little finger.

2 The thenar eminence, composed of the abductor,
 adductor, flexor and opponens muscles of the
 thumb.

3 Palmar fascia and the fibrous expansion of the
 palm.

4 Palmaris longus—arises from internal condyle of
 the humerus, passes over the annular ligament
 and ends in the palmar fascia. (Page 55)

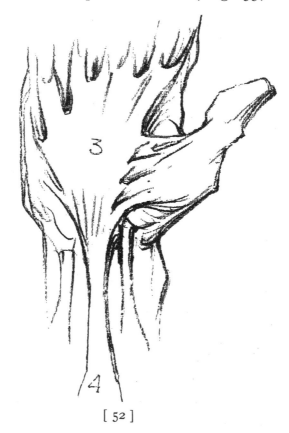

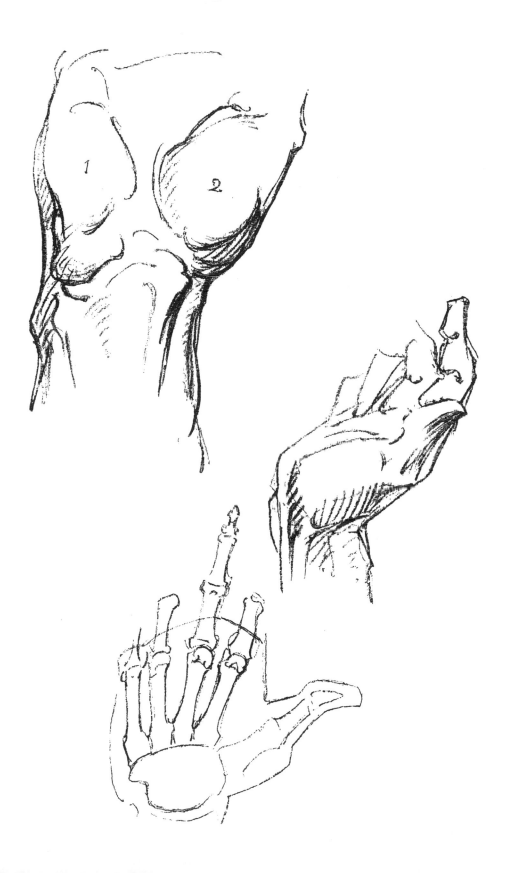

THE HAND
Palmar View

The mounds of the palm are beyond the line of knuckles on the back, lying over the enlarged ends of the first phalanges.

They are flattened, bulged or wrinkled, according to the position of the fingers.

The hollow of the palm is triangular, traversed by the tendon of the middle finger.

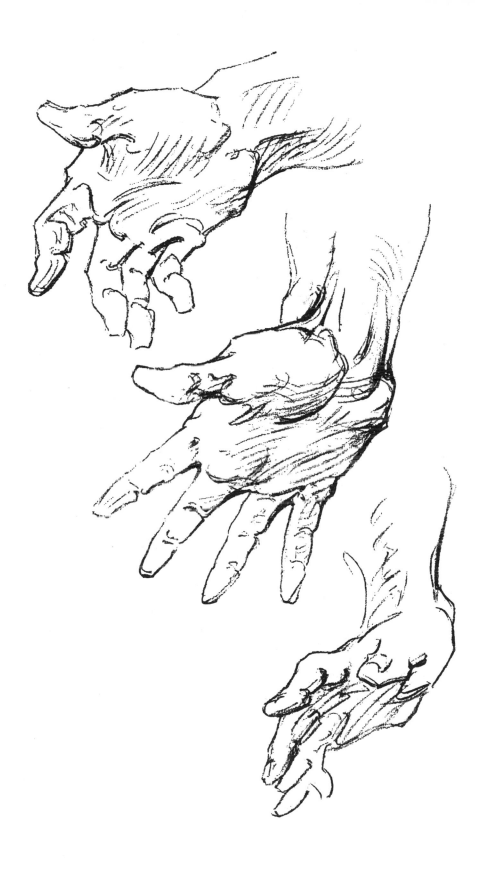

THE HAND

ORIGIN, INSERTION AND ACTION
OF MUSCLES
Pages 169-171

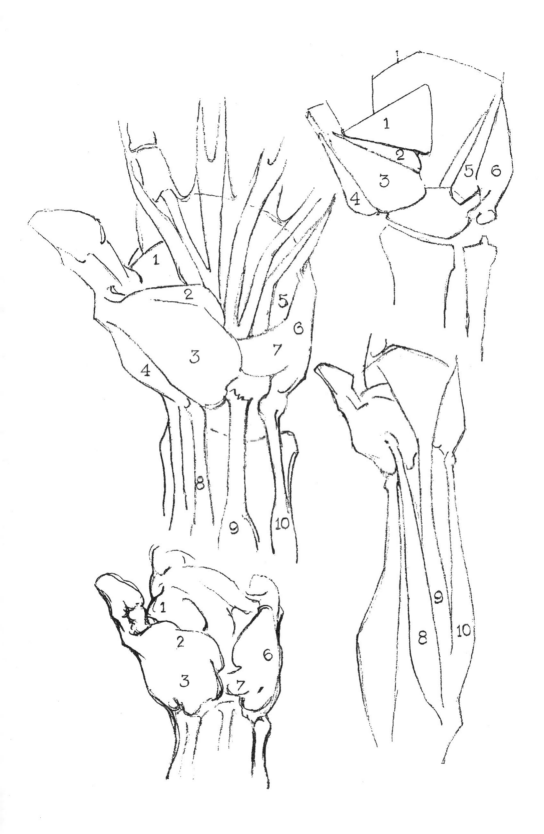

THE HAND

PALMAR VIEW

It is usually the middle finger that is found most hooked, on account of its greater strength.

It is usually the first and little fingers that assume extreme positions, on account of their greater flexibility.

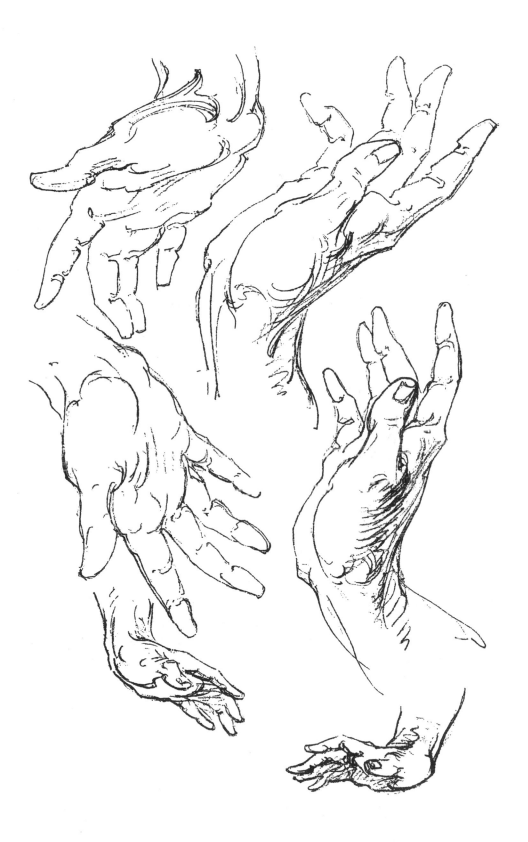

THE HAND

Construction

In the hand as in the figure there is an action and an inaction side. The side with the greatest angle is the action side, the opposite is the inaction or straight side.

With the hand turned down (prone) and drawn toward the body, the thumb side is the action side, the little finger the inaction side. The inaction side is straight with the arm, while the thumb is almost at right angles with it.

The inaction construction line runs straight down the arm to the base of the little finger. The action construction line runs down the arm to the base of the thumb at the wrist, from there out to the middle joint, at the widest part of the hand; thence to the knuckle of the first finger, then to that of the second finger, and then joins the inaction line at the little finger.

With the hand still prone, but drawn *from* the body, the thumb side is the inaction side, and is straight with the arm, while the little finger is at almost right angles with it. The inaction construction line now runs straight to the middle joint of the thumb, while the action line runs to the wrist on the little finger side, thence to the first joint, etc., etc.

These construction lines, six in number, are the same with the palm turned up, according as it is drawn in or out. They place the fingers and indicate the action and proportions of the hand.

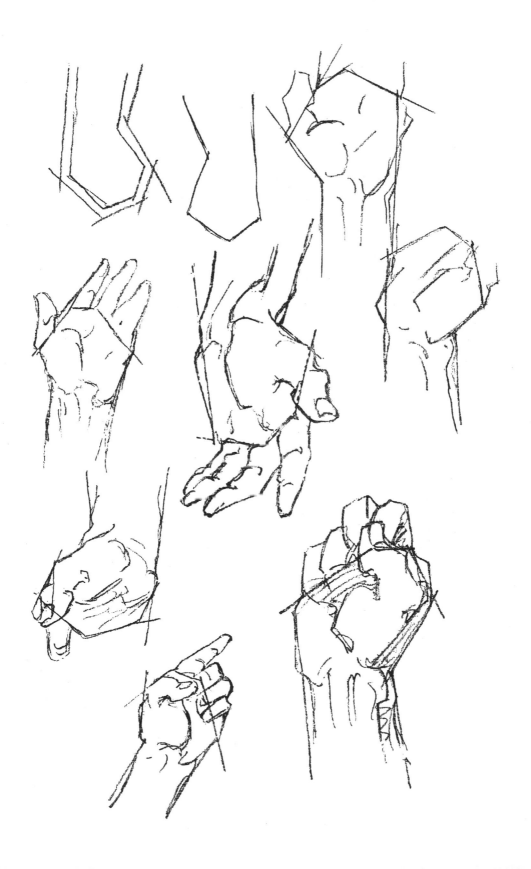

THE HAND

PALMAR VIEW

In the hand are four bones, continuous with those of the fingers, called metacarpals (*meta,* beyond, *carpus,* wrist). They are covered by tendons on the back, and on the front by tendons, the muscles of the thumb and little finger, and skin pads.

The short muscles of the hand, crossing only one joint, the knuckle, and moving the fingers individually, lie deep between the metacarpal bones and so are called interossei. They are in two sets, back and front, or dorsal and palmar. The palmar interossei are collectors, drawing the fingers toward the middle finger, and so are fastened to the inner side of each joint except that of the middle finger itself. The dorsal interossei are spreaders, drawing away from the centre, and so are fastened to both sides of the middle finger and to the outside of the other joints.

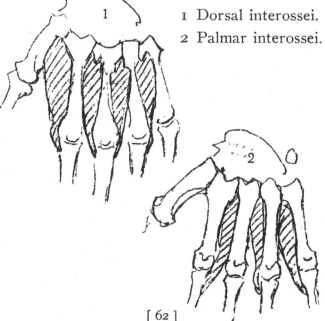

1 Dorsal interossei.

2 Palmar interossei.

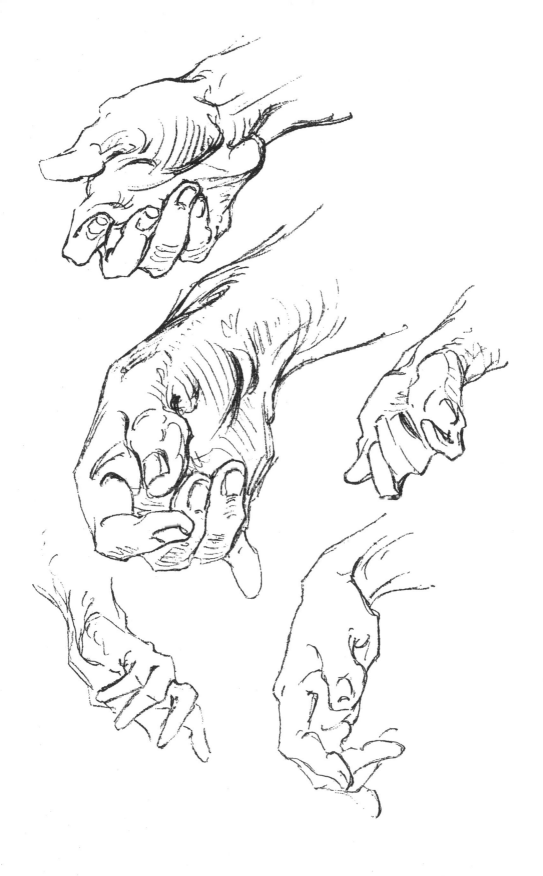

THE HAND

Palmar View

1 Abductor pollicis.

2 Flexor brevis pollicis.

3 Adductor transversus pollicis.

4 Lumbricales.

5 Annular ligament.

6 Abductor minimi digiti.

7 Flexor minimi digiti.

ORIGIN, INSERTION AND ACTION
OF MUSCLES
Pages 169-171

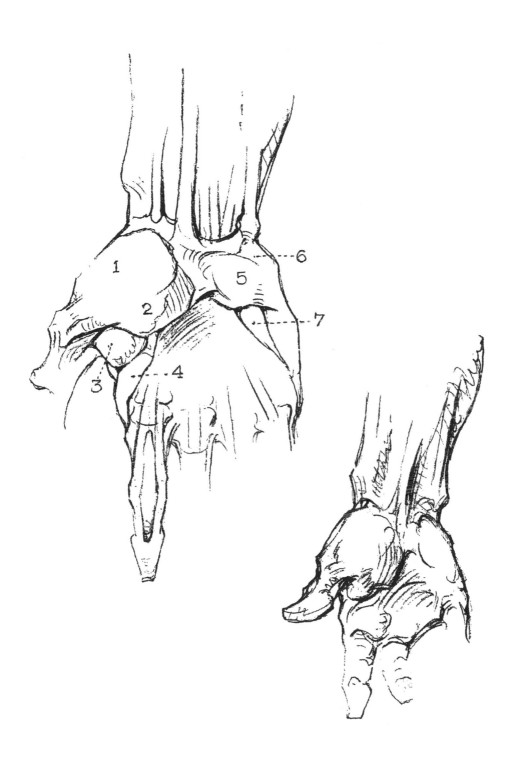

THE HAND
THUMB SIDE

THE HAND
THUMB SIDE

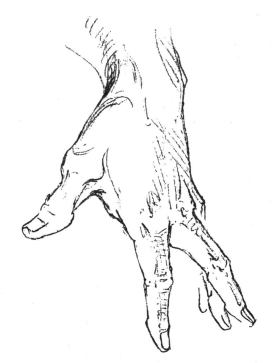

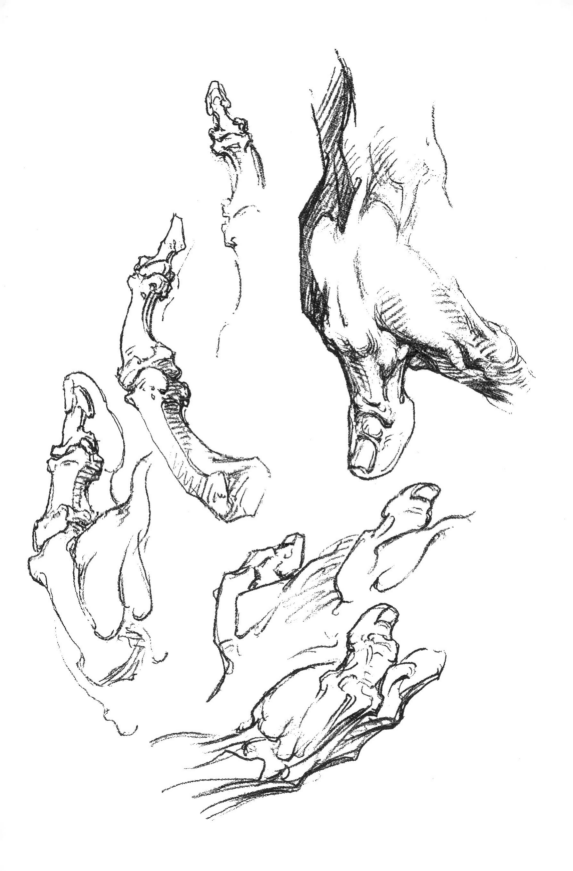

THE HAND

Thumb Side

Between the knuckle of the first finger and the thumb is a bulging mass. This is the first interosseous muscle, large here on account of the exposed position of the finger, also because it aids the thumb. In clasping, it is perpendicular to the thumb and diagonal to the knuckle. It attaches to the phalanx at the knuckle, to the whole side of the thumb (first segment) and to the base of the metacarpal bone of the finger itself.

Beyond its edge is a fold of skin; alternately drawn into a half-moon blade, and dimpled and wrinkled, as the thumb changes its position.

Running the length of the thumb to the last joint, on its back, is seen the extensor tendon, pointing always to the top of the wrist. At the root of the thumb is seen another tendon, that of the short extensor, pointing always to the bottom of the wrist; the two converging on the second joint. Between them at the wrist is a depression, quite deep when the thumb is extended.

This latter tendon marks the front border of the metacarpal bone of the thumb. Bulging in front of it are, first, the trapezium, marking the radial end of the wrist arch, then the thenar eminence, to the big joint of the thumb. Sometimes the basal joint of the thumb still farther bulges this eminence.

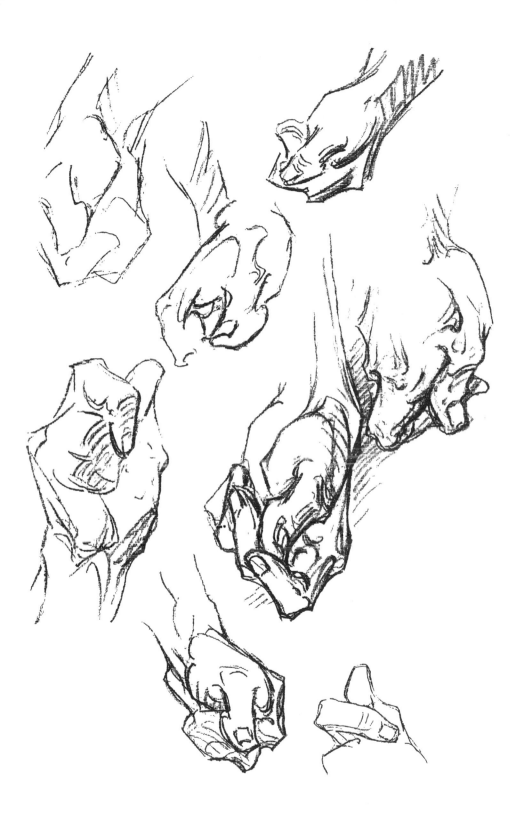

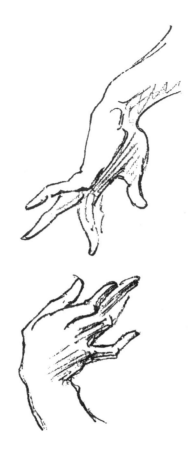

THE HAND

The female hand differs from that of the male chiefly in the smaller size of the joints and knuckles, the smaller and less conspicuous bones, and the fineness of skin texture. There is a more fundamental difference also: the long outside muscles, those crossing more than one joint, are usually better developed in men, the short muscles that hug the bones and lie close to the joints, crossing only one joint, are as a rule more developed proportionately in women.

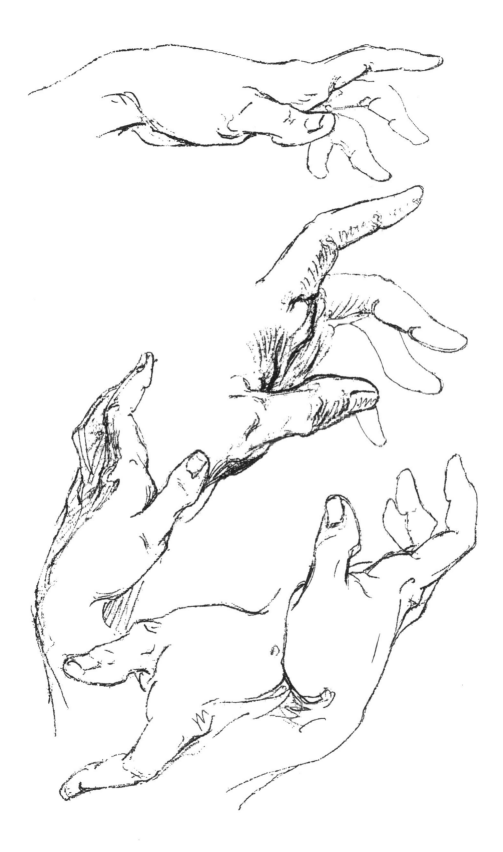

THE HAND

Thumb Side

The mass of the hand sets at an angle across the end of the forearm; the mass of the thumb sets at an angle across the base of the hand.

The Muscles of the Thumb

1 Long extensor of the thumb.
2 Short extensor of the thumb.
3 Long abductor of the thumb.

Origin, Insertion and Action of Muscles

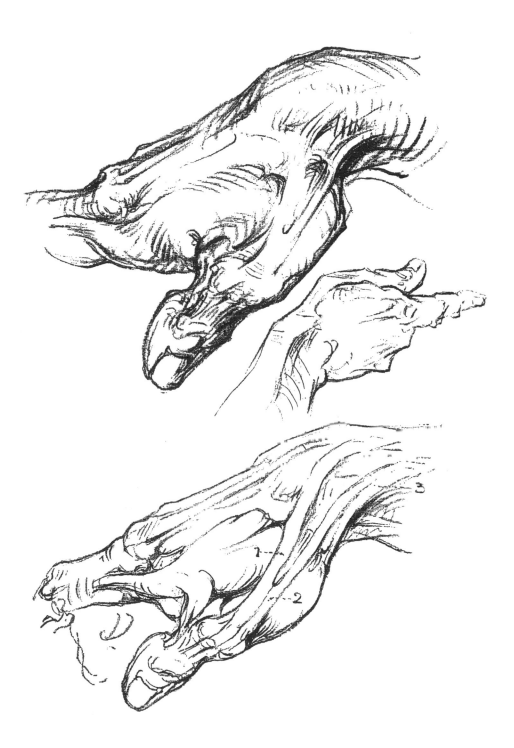

THE HAND

THUMB SIDE

The power of the thumb depends chiefly on its short muscles. Muscles must be long in proportion to the distance they have to contract. Muscles to the ends of fingers and thumb are therefore long, reaching to the elbow. Those of the first and middle segments of the thumb (the latter with very little movement) are short and are developed about the segment and across the palm, where they act in direct line with the movement of the bone. The power produced by muscular action depends on the leverage and the angle at which it is applied. The long muscles act at an acute angle, with rapid movement but little power. These short muscles being in direct line produce great power but are relatively slow. The fastest movement of the thumb is therefore slow compared to that of the fingers; its power is proportionately greater.

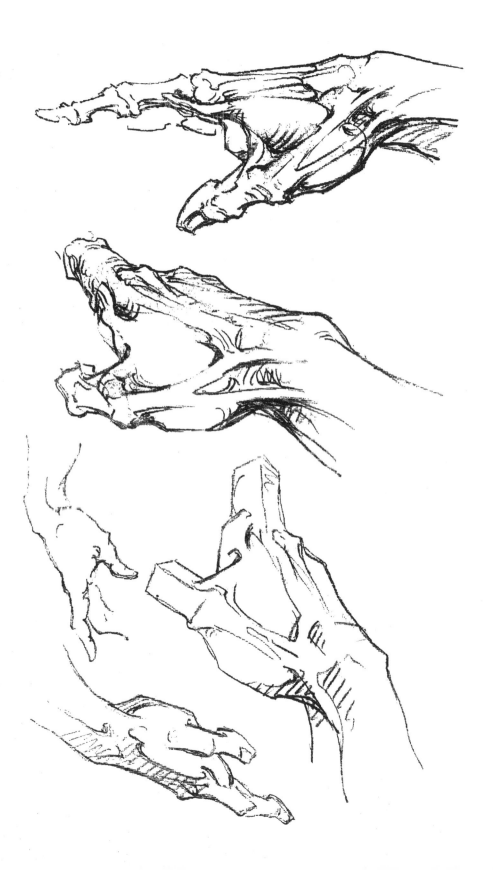

THE HAND
THUMB SIDE

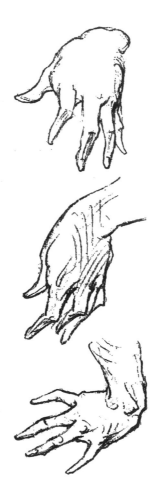

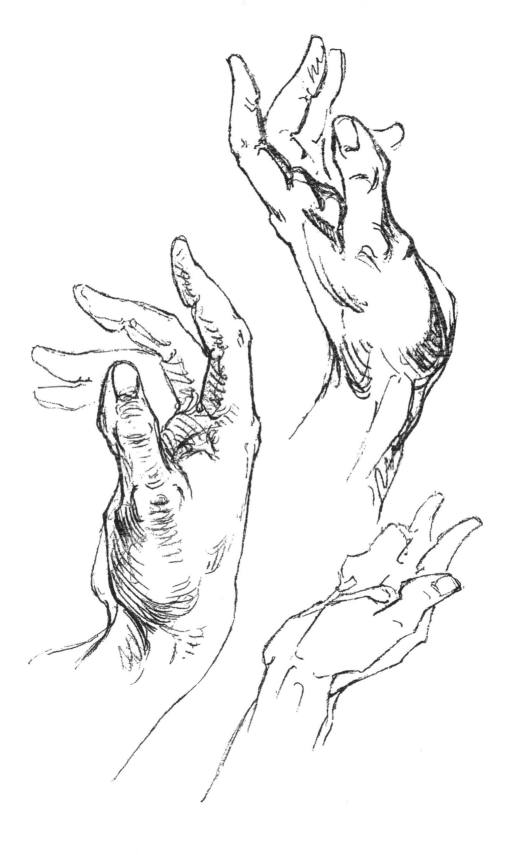

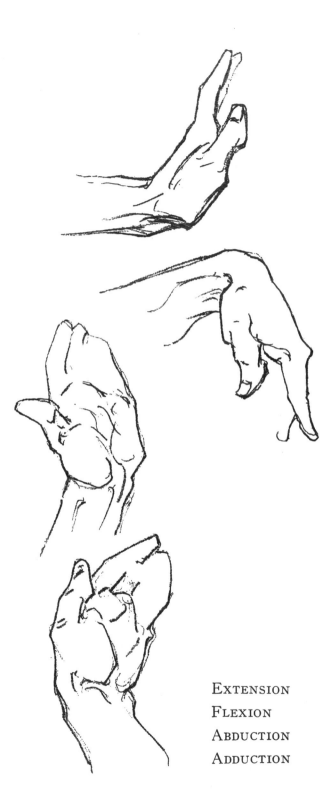

EXTENSION
FLEXION
ABDUCTION
ADDUCTION

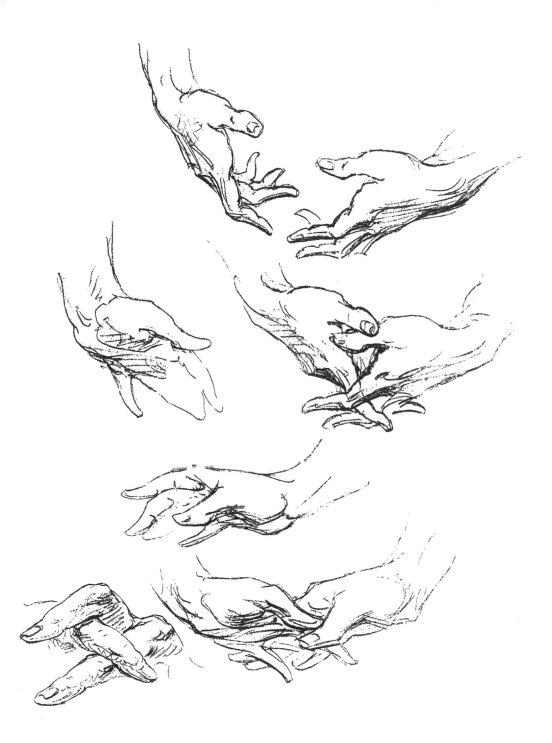

THE HAND

THUMB SIDE

Distinguishable under the skin of the thumb (palmar side) are three muscles, sometimes a fourth. These, from the back forward, are the fat opponens, hugging the bone; the broad abductor, forming the bulk of the mass; and the thin flexor brevis, inside. Deeper and reaching transversely across the hand is the adductor muscle, which throws the skin of the palm into a bulging wrinkle when the thumb is flattened back.

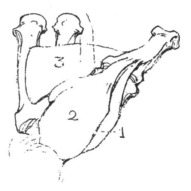

1 Opponens pollicis.

2 Abductor pollicis.

3 Adductor transversus.

Pages 169-171

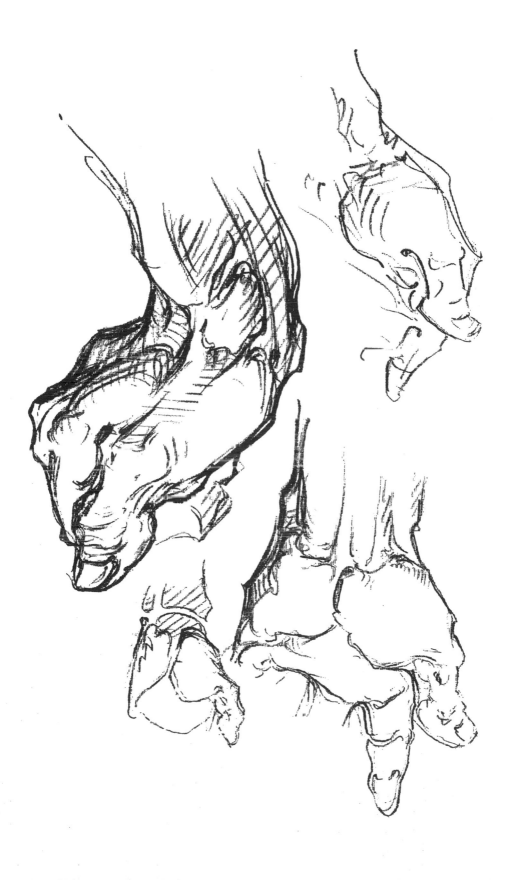

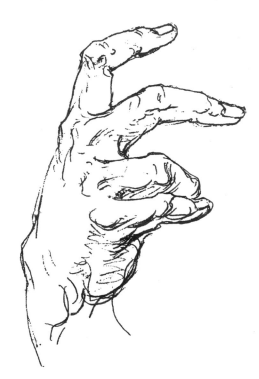

THE HAND

THUMB SIDE

The little finger side of the hand is the pushing side; the little finger side of the wrist is the heel side. The thumb side of the hand is the pulling side. Since pulling is so much more important a function of the hand, the thumb side of hand and wrist and all the bones of that side, with the first two fingers, are larger.

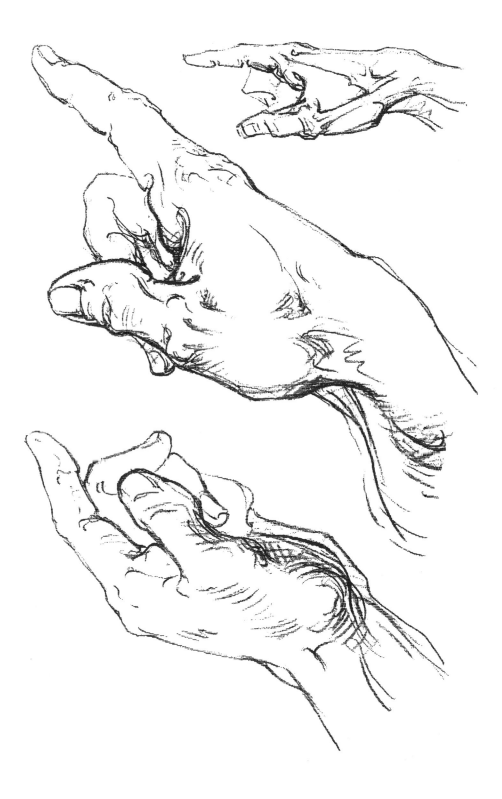

THE HAND

Origin, Insertion and Action
of Muscles
Page 169

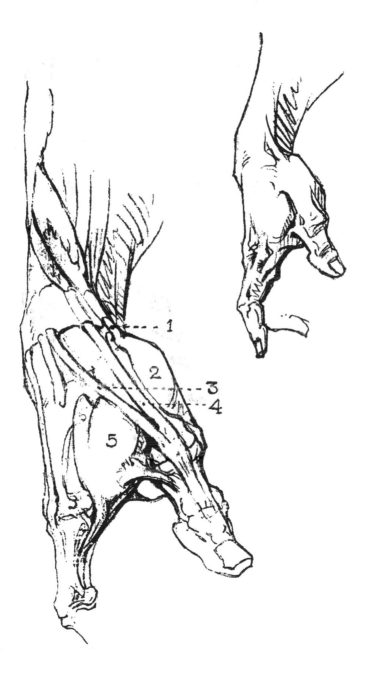

THE HAND
LITTLE FINGER SIDE

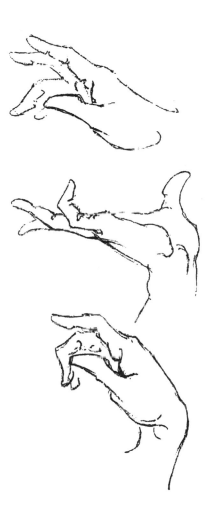

THE HAND

LITTLE FINGER SIDE

The little finger side of the hand sets across the end of the forearm at a sharper angle than does the thumb side.

It is narrower and never wholly conceals the rest of the hand.

The pisiform bone, or heel of the hand, is always conspicuous on the lower side of the wrist.

To it attaches the flexor carpi ulnaris muscle, corresponding with the tendon of Achilles.

1 Pisiform (pea-shaped) bone.

2 Flexor carpi ulnaris.

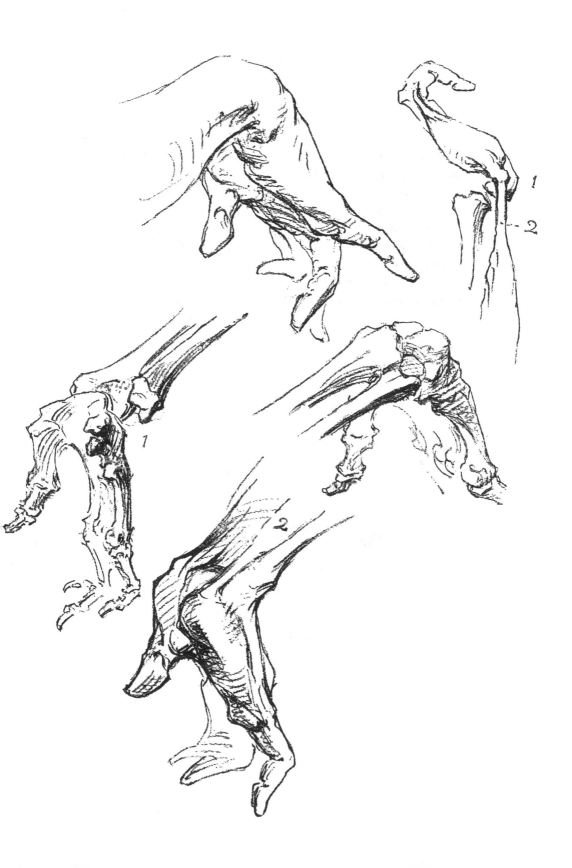

1

2

1

2

THE HAND

Little Finger Side

In resting the wrist on a table, the weight should rest on the pisiform bone. Instinct protects the more sensitive unciform bone, on the thumb end of the wrist arch.

In this position the fingers are always curled up or arched, on account of the shortness of the flexor tendons.

1 Pisiform bone.

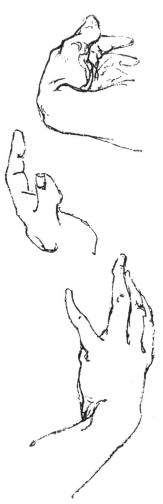

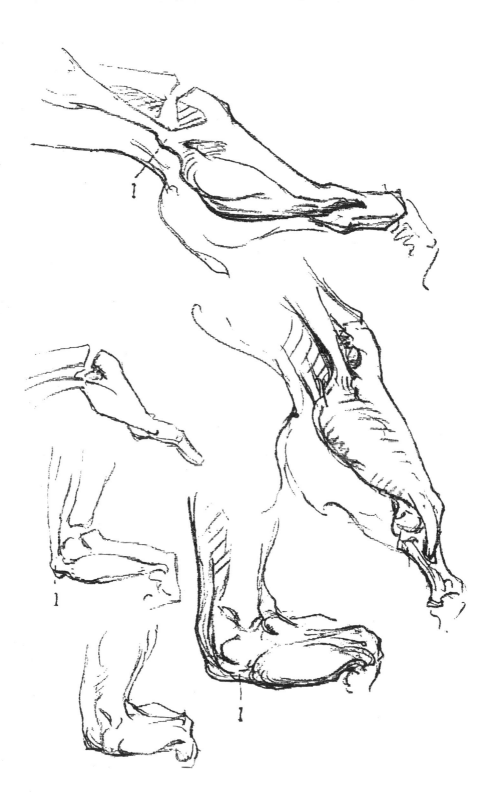

THE HAND

LITTLE FINGER SIDE

1 Abductor minimi digiti. 3 Flexor carpi ulnaris.
2 Annular ligament. 4 Pisiform bone.

ORIGIN, INSERTION AND ACTION
OF MUSCLES
Pages 169-171

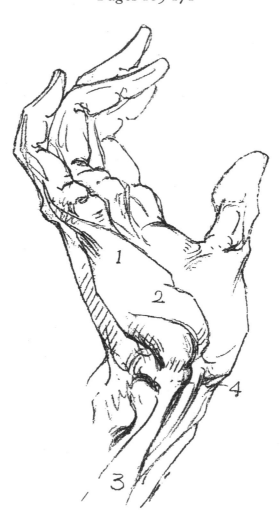

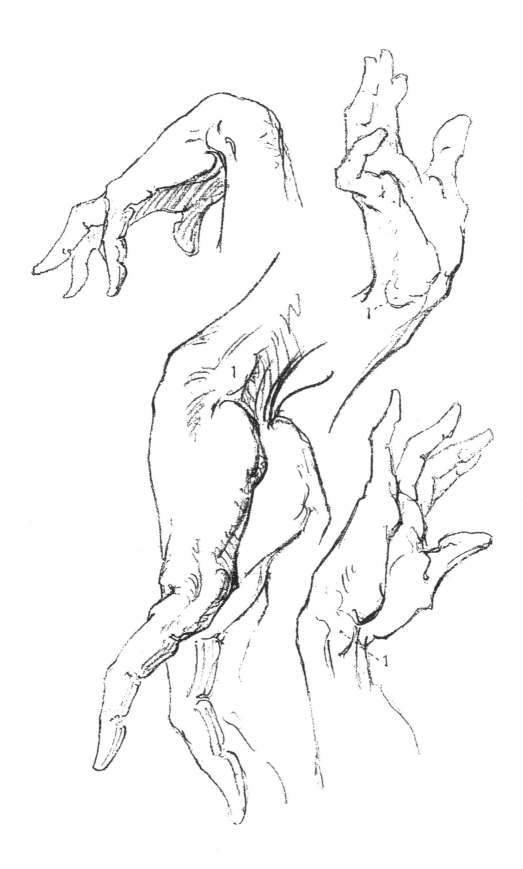

THE HAND

LITTLE FINGER SIDE

Beyond the pisiform, after a small tendinous interval, is the abductor minimi digiti muscle, running to the outside of the knuckle of the little finger.

1 Abductor minimi digiti.

2 Flexor carpi ulnaris.

ORIGIN, INSERTION AND ACTION OF MUSCLES

Pages 169-171

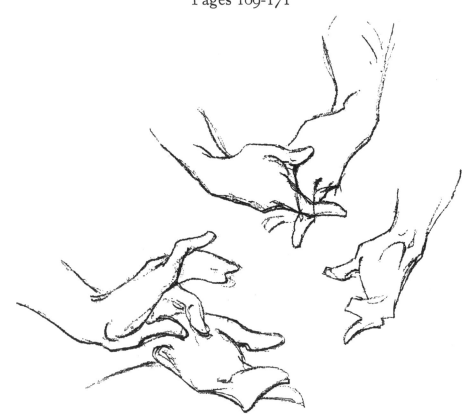

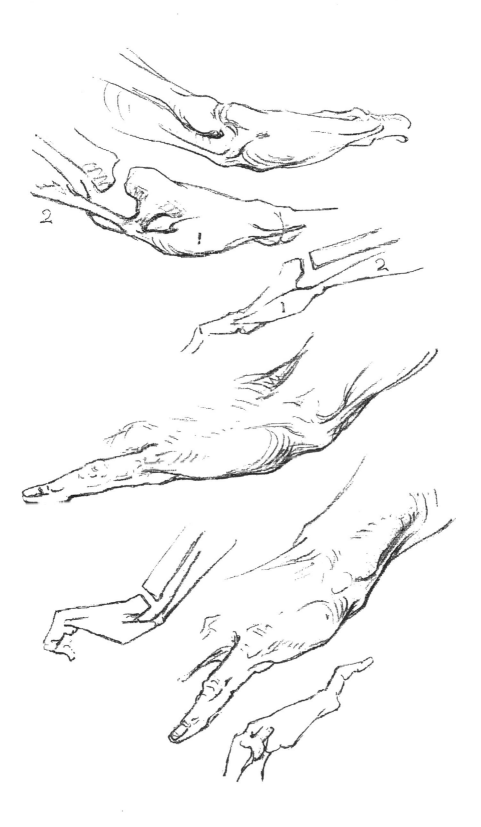

THE THUMB

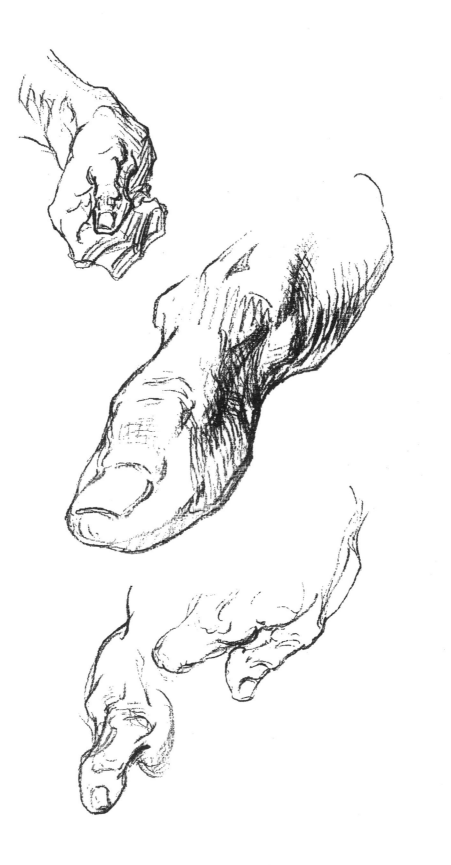

THE THUMB

The thumb, extended, faces half frontways; flexed it faces across the palm, and may by pressure be bent slightly toward it.

It may touch the side of the first finger, but otherwise cannot touch the palm. It is the fingers that are brought down to touch it.

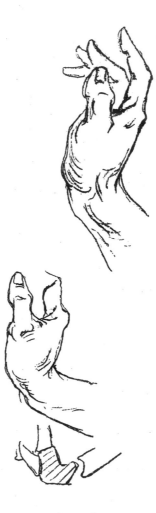

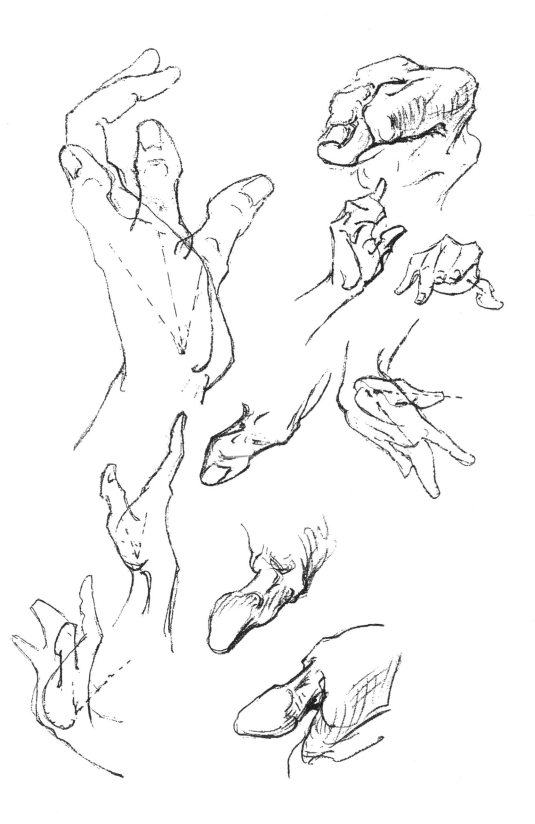

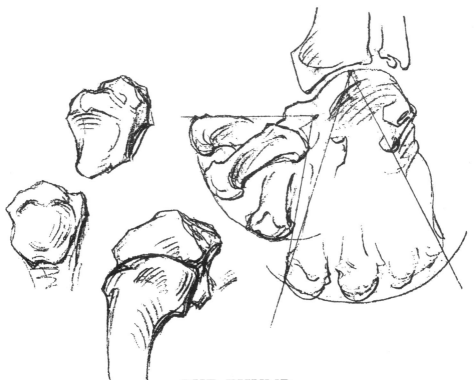

THE THUMB

Saddle Joint

The range of movement of the thumb is slight—half a right angle at the base, much less at the middle joint, a right angle at the last joint.

The basal joint is a saddle joint, permitting half a right angle of movement sideways, and very much less fore and aft. The middle joint is extra large in proportion to others on account of its exposed position, permitting slight flexion and very slight torsion. It is built for strength rather than movement. The last joint with its long muscle reaching to the elbow has a right angle of movement (this long muscle must take up the slack of the other joints, including the wrist, also).

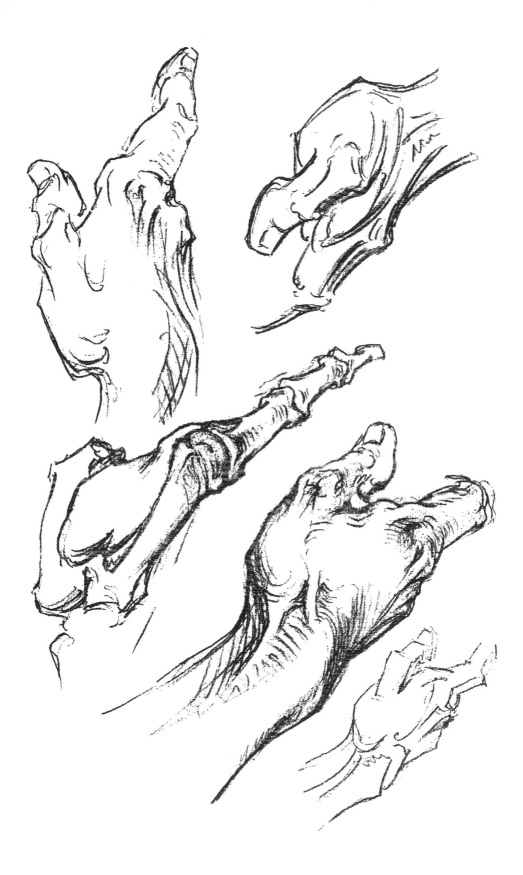

THE THUMB

The mass of the thumb is in three parts. That of the base is pyramidal, extending forward from the radial edge and half of the front side of the hand; its base reaching to the "line of life" of the palm and to the amulet wrinkle of the wrist; its apex at the middle joint. Its faces are rounded and bulging except at the back where the bone is superficial and the thick tendon may be seen.

Angling inward from this apex rises the second part, slender, square with rounded edges, with a thin pad in front.

Balanced sharply backward across this is the last part, pear-shaped, carrying the nail. Its skin pad, or ball, faces to the front more than sideways. It is broad at the base, where it covers the exposed extremity of the middle segment in extension, giving an appearance not unlike a foot as it presses against some object. Its tip reaches to the middle joint of the first finger.

The mass of the thumb may bend under the hand to about the centre, where it is invisible from the back except a curved root. It may bend out to about a right angle. It bends back very slightly if at all, except at the tip. Between thumb and palm, as also on the back, a roll of flesh may be raised by pressure of the thumb, and is drawn into a thin curved blade when stretched.

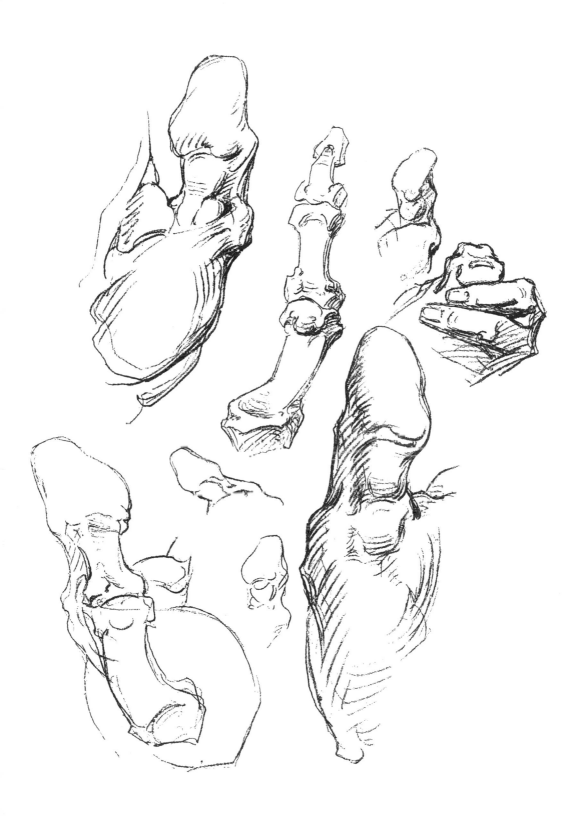

THE THUMB

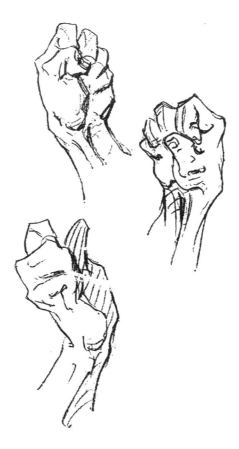

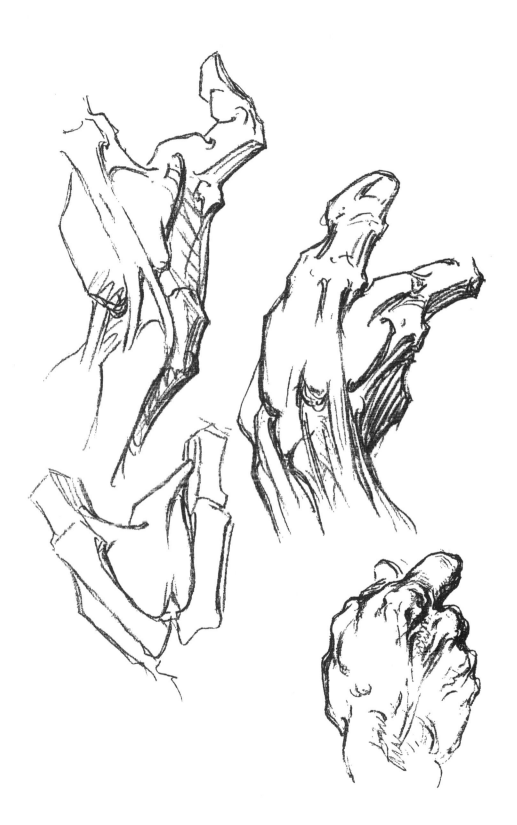

FINGERS

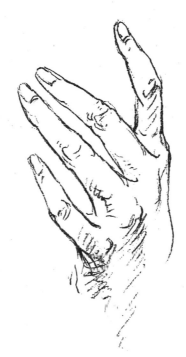

FINGERS

1 SECTIONAL VIEW—First finger between knuckle and second joint.

2 SECTIONAL VIEW—Between second and third joint.

3 SECTIONAL VIEW—Last joint at nail.

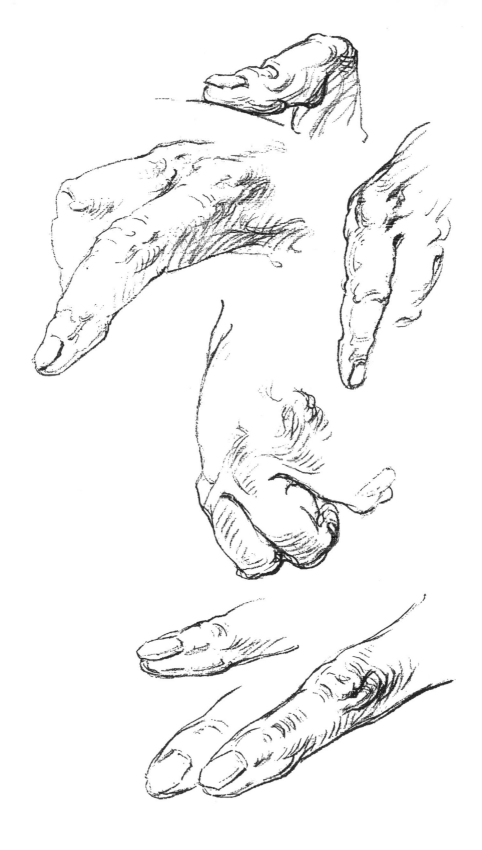

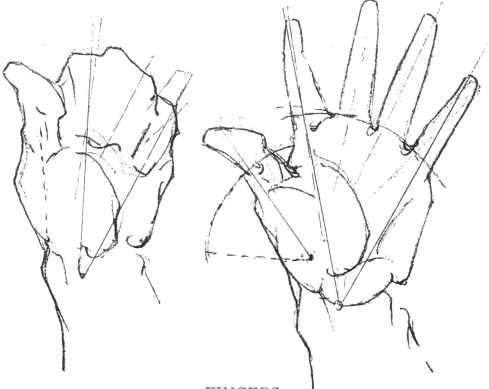

FINGERS

From the centre of the arch of the wrist radiate
the tendons of the long muscles to the fingers; and
the fingers must be in line with their power, to
prevent warping, so radiate from this point. But
the power of the thumb has drawn the centre of
radiation a trifle to its side of the wrist, so that the
mechanisms of the hand are grouped around a point
near its base. The clenched fingers all point to this
centre, as far as crowding will permit. Half closed,
as in clasping, they form arches converging there.
In any position except a strained one the rows of
knuckles form arches whose common centre is this
point.

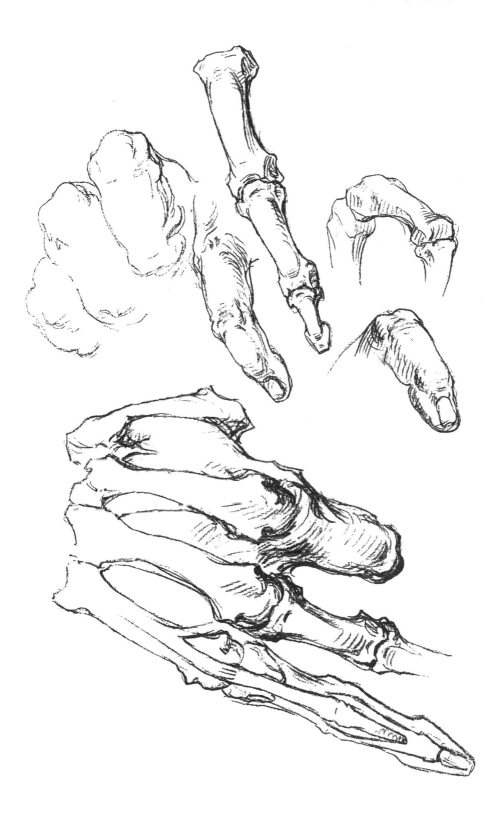

FINGERS

The webbing between the fingers runs up to the middle of the first segment on the palm side. Thence it bevels backward between the fingers to a point at the apex of the knuckles; which point it never reaches, but sinks in between the knuckles.

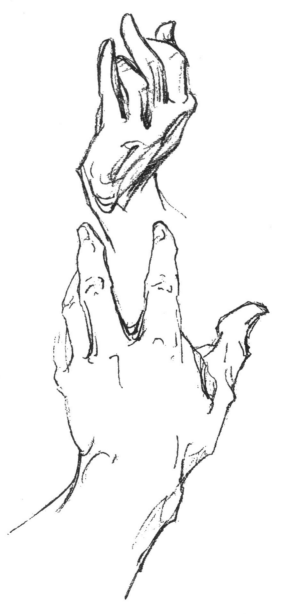

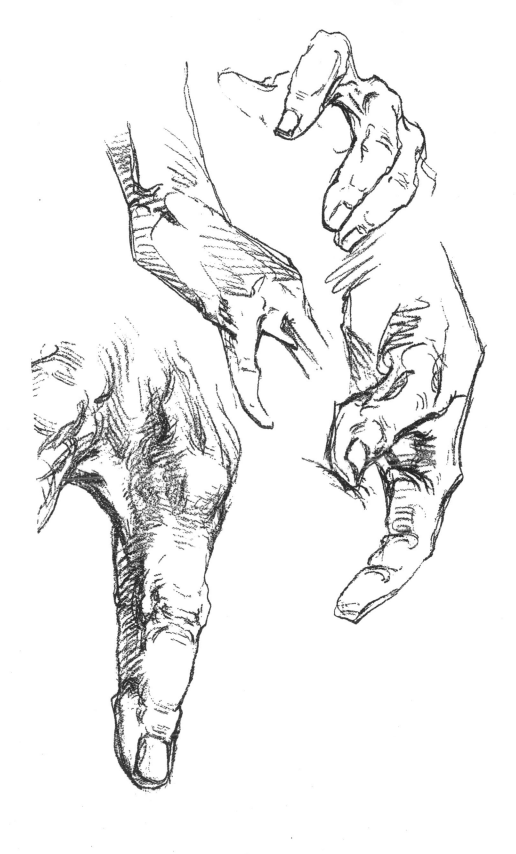

FINGERS

The skin pads are of approximately the same length, as necessary when the finger is tightly closed, but the segments are of different lengths; so the creases are not opposite the joints.

In the first finger the creases are beyond the knuckle, opposite the middle joint, and short of the last; in the second finger they are beyond the knuckle, beyond the second joint, about opposite the last; in the third finger they are beyond the knuckle, beyond the second. The other positions vary in different individuals.

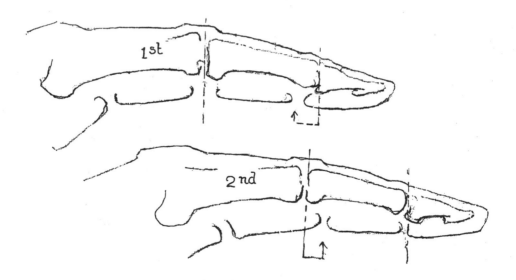

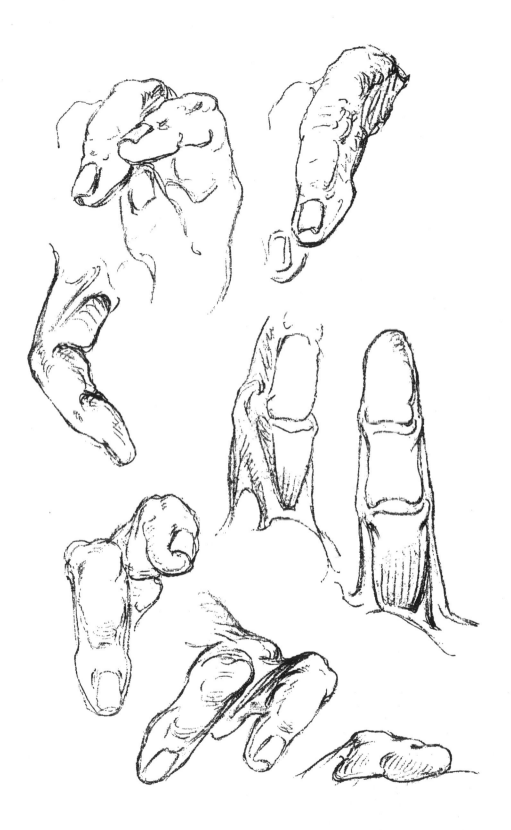

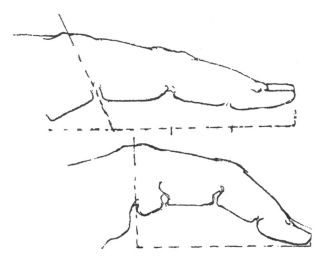

FINGERS

On the palmar surface, when the fingers are straight, the palm extends beyond the knuckles half way to the next joint; but when the fingers are bent, a portion bends with them, and belongs with them; so that when bent the fingers on the palmar side start from the knuckle.

Thus when straight the fingers have three pads; when bent they have four.

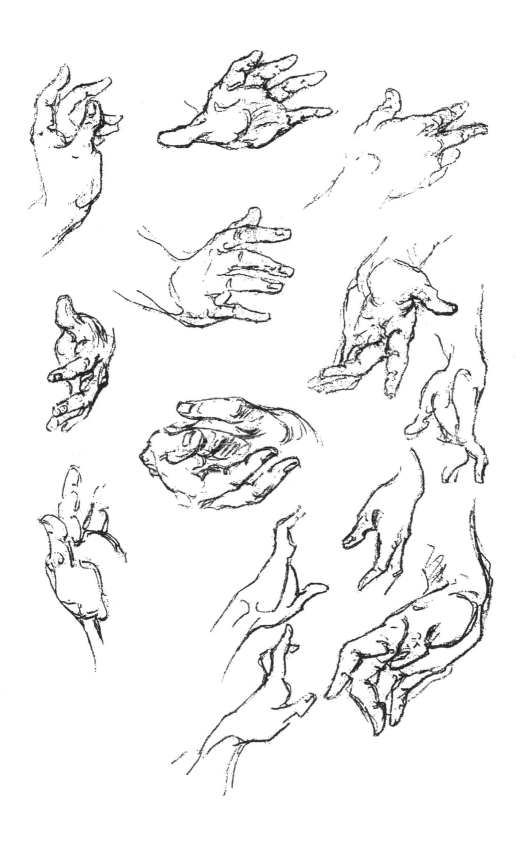

FINGERS

When curled close, the ends of the fingers just
cover the heads of their first phalanges; that is, they
lie with their tips against the knuckles, supporting
them. This is a mechanical necessity in fitting the
fingers into the fist (page 124).

Thus the two outer segments are longer than the
first (page 130), but when measured from the back
of the knuckle, the first segment is equal in length
to the latter two.

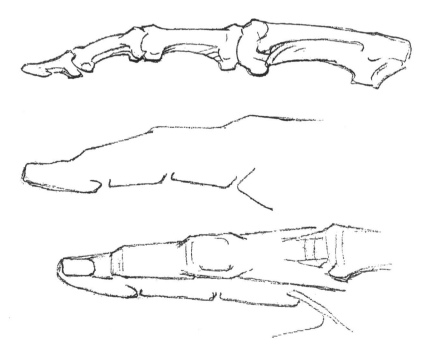

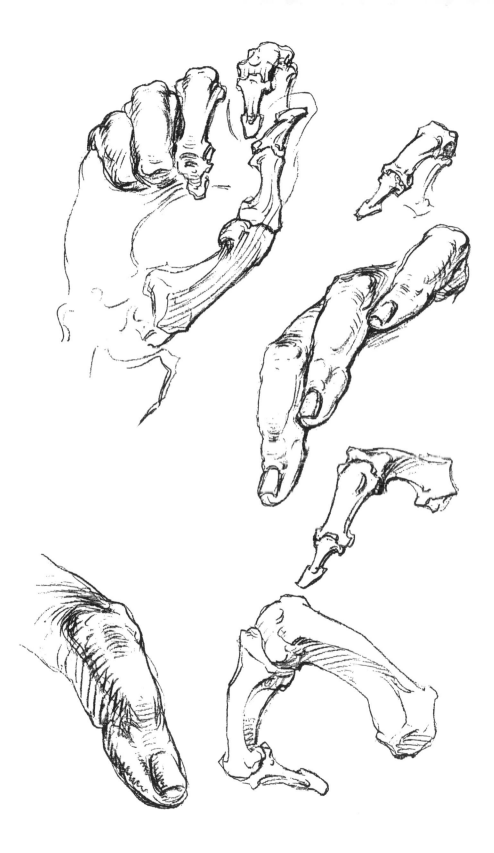

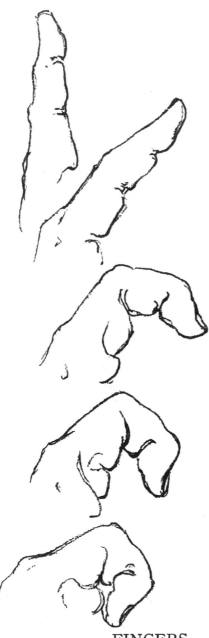

FINGERS

In flexing, the finger bends first at the knuckle,
then at each joint in turn.

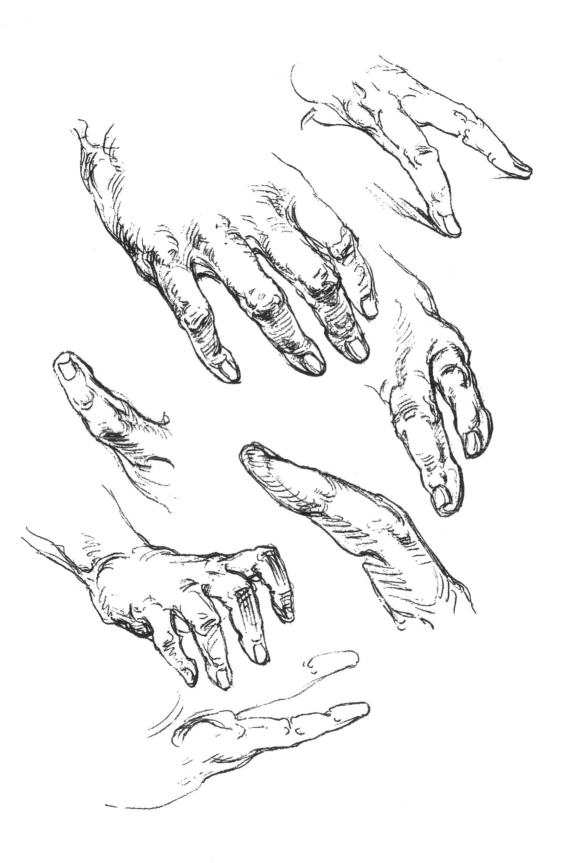

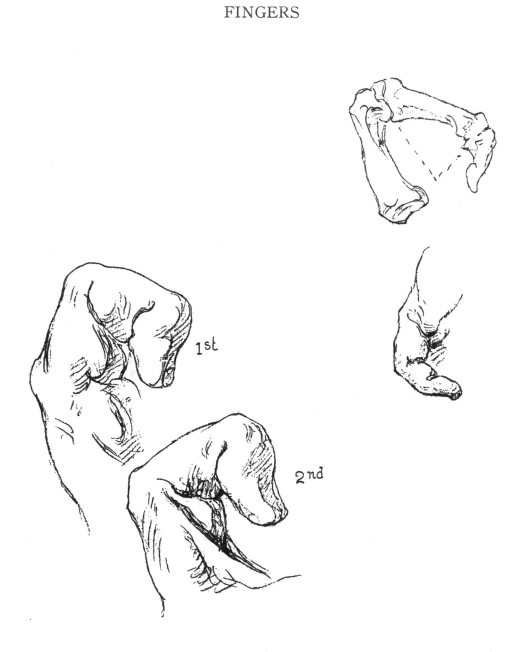

1st

2nd

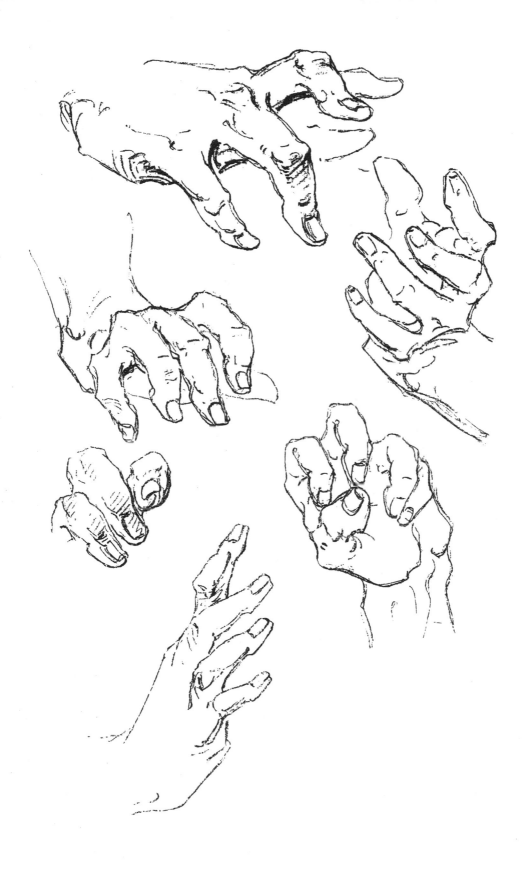

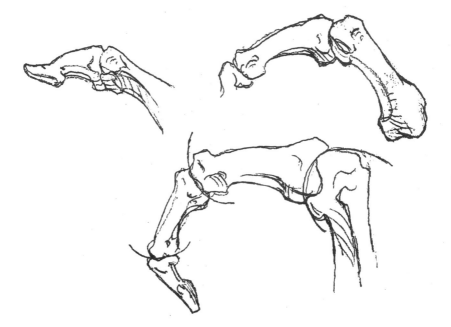

FINGERS

The joints of the fingers are built like shallow saddle joints; that is, one reaches up on the sides, the other reaches down on the front and back.

In every case it is the more distant bone that turns on the convex end of the nearer bone, leaving the end of the latter exposed in flexion.

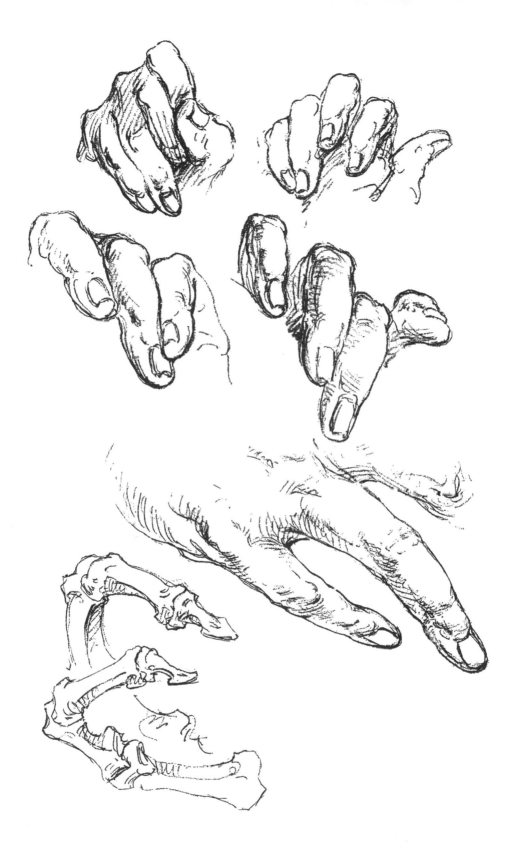

FINGERS

1, 2, 3, 4 Bones, tendons and sheathing of the fingers, palm side.

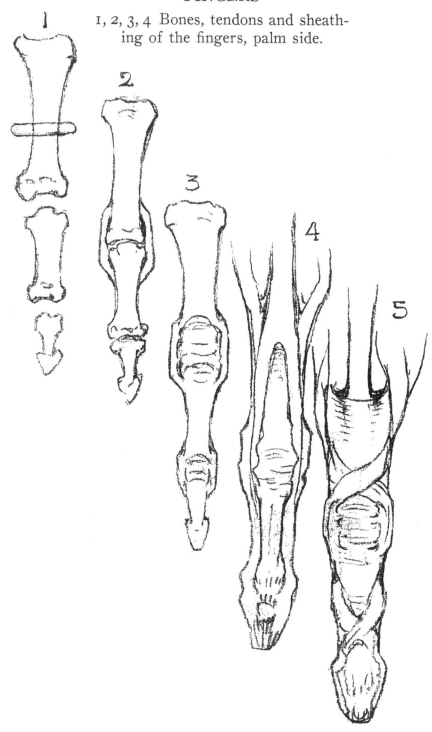

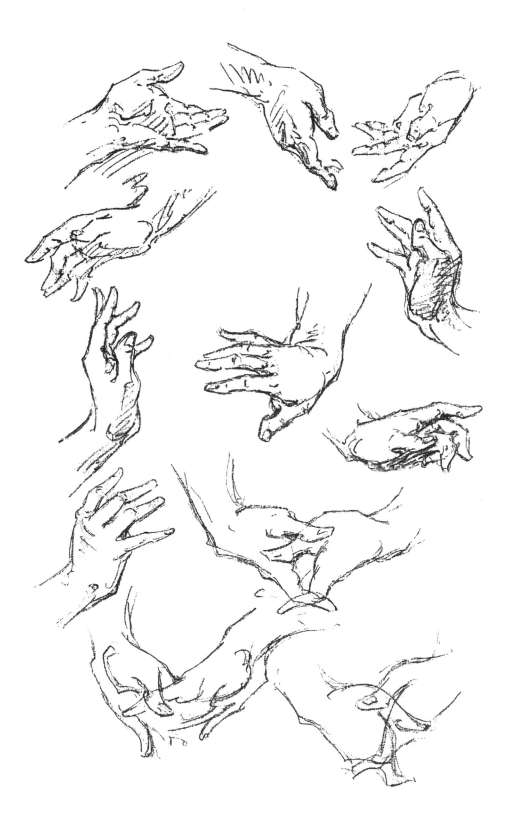

FINGERS

Opposite the three bones of the finger are four skin pads; the pads therefore smaller.

The first joint is about equal to the last two, measuring from back of the knuckle (though the bone itself is shorter). When the three joints are bent to form three sides of a square, the four pads fill in the quarters of it. Three of the grooves between them are diagonals, with two other grooves irregularly placed.

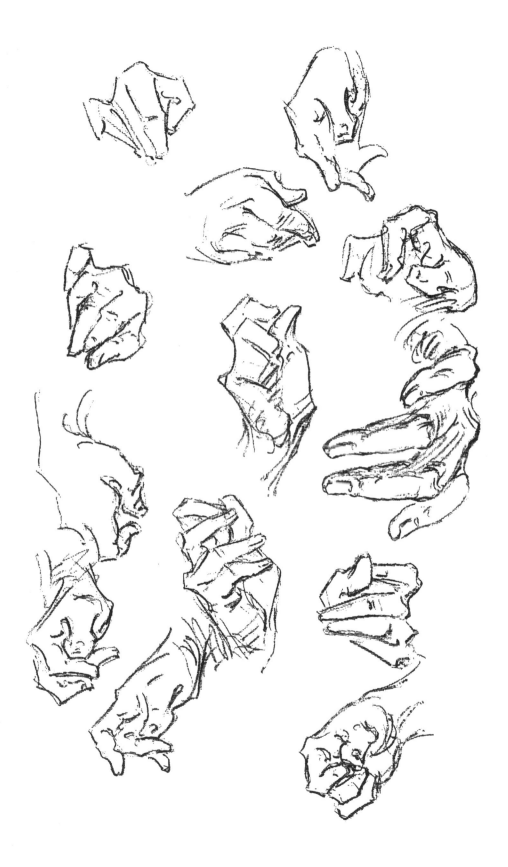

KNUCKLES

There is no muscular covering for the knuckles; only the tendons, which are half blended with them, and roughened skin.

In clenching, this skin is tightly stretched, and by contact with objects is hardened, so that in other positions it is wrinkled.

The end of the metacarpal bone is a round dome, over which fits the socket of the first phalanx. The dome is protected on the sides by square projecting flanges, which are matched by the sides of the socket. They are in the first finger set at a slight diagonal, so that there is an overhang of the phalanx, serving to protect the joint in lateral blows.

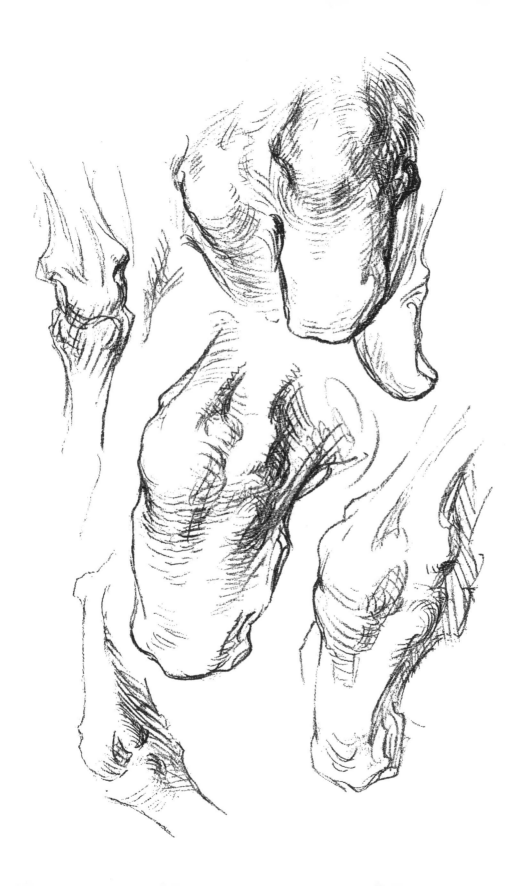

KNUCKLES

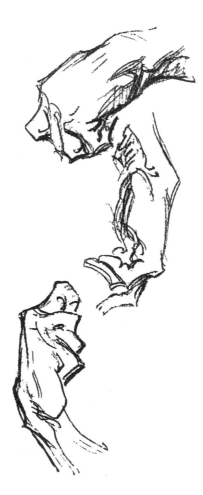

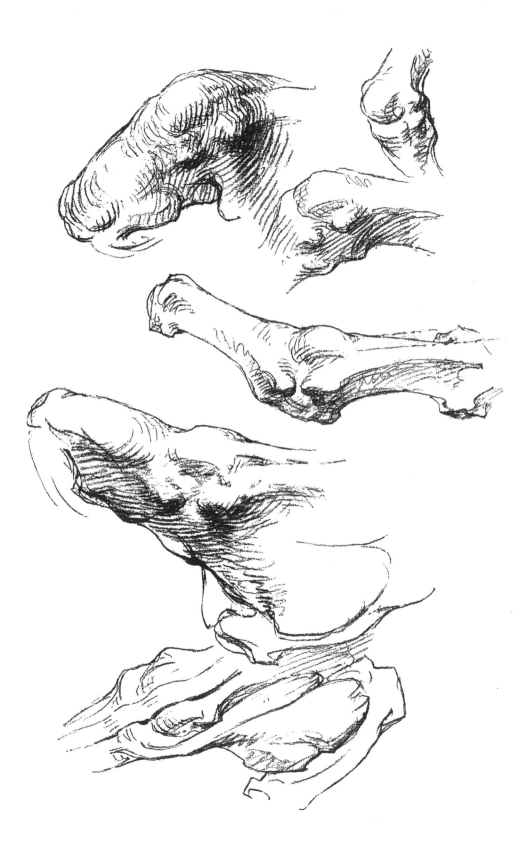

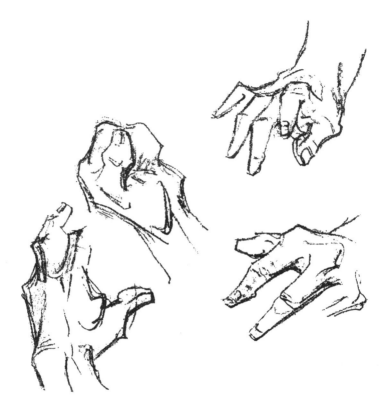

KNUCKLES

1 Tendons of the extensor communis
 digitorum.
2 Dorsal interosseous muscles.

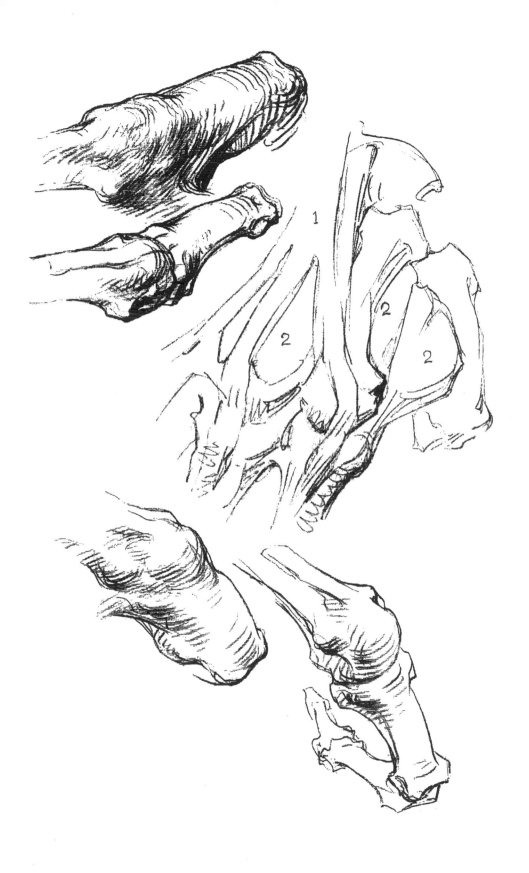

THE FIST

THE FIST

The hand, open, is an implement.

The hand, closed, is a weapon.

When driven forward, the second knuckle, as the most prominent, becomes the point of impact; but in clenching it is braced by the entire fist, bone, tendon and knuckle.

When driven directly forward, the second knuckle is in line with the wrist and the radius, making a straight battering ram.

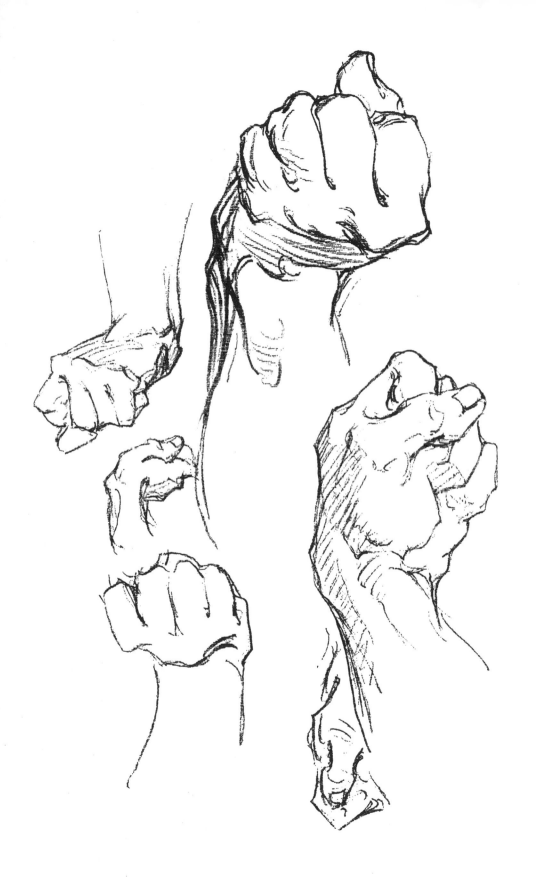

THE FIST

The fist bends back to almost a right angle with the forearm, and bends forward to slightly less; but between front edge and back edge of the fist is a considerable angle; so that its total movement in this direction is barely more than one right angle. The amount of lateral bending is barely more than half a right angle.

The fist bends more easily backward than forward, and more easily to the little finger side than to the thumb side, on account of the position in clasping an object.

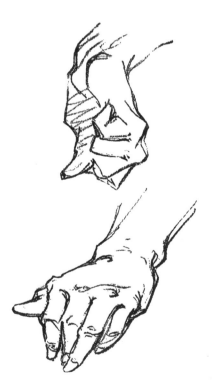

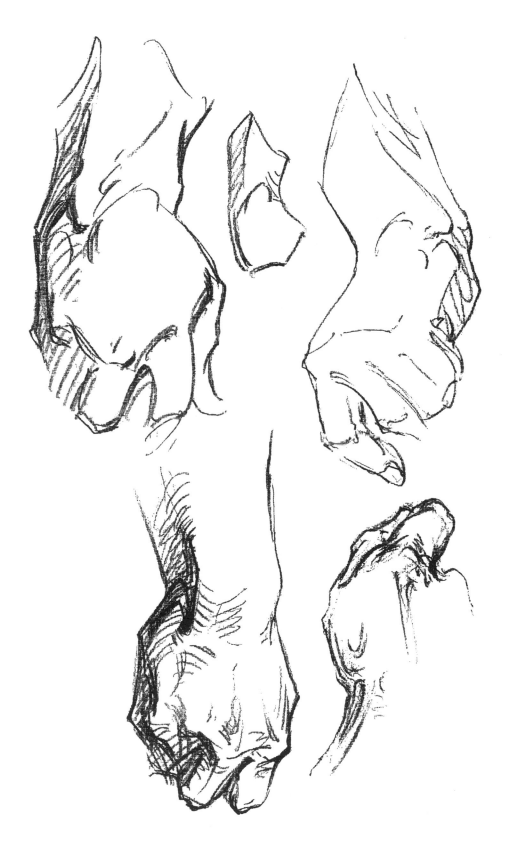

THE FIST

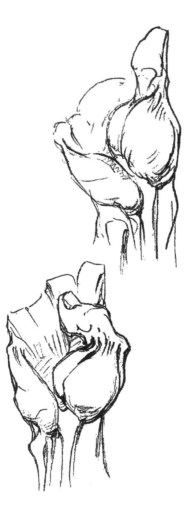

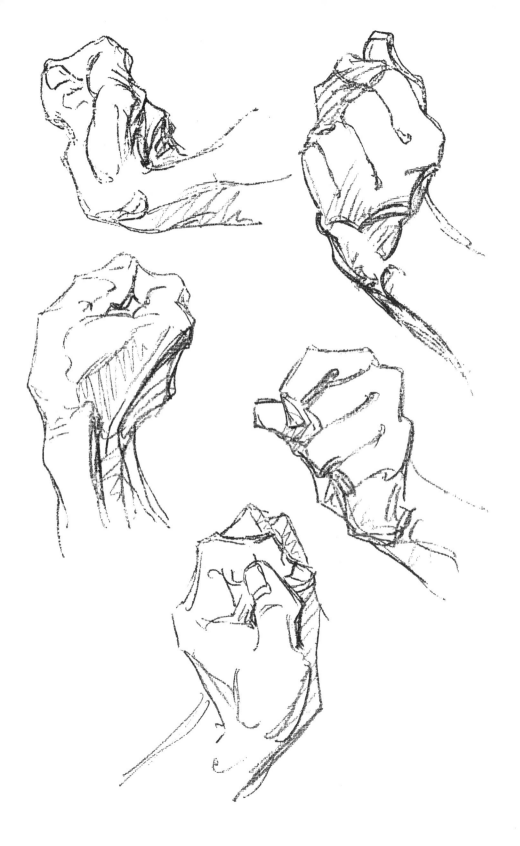

THE FIST

The blow with the fist falls on the knuckle of the second finger, which is the longest, strongest, and in line with the radius.

The more tightly it is clenched, the more it is arched across the knuckles.

The bones of the second row lie in the same plane.

The thumb lies against the first finger, or across the second.

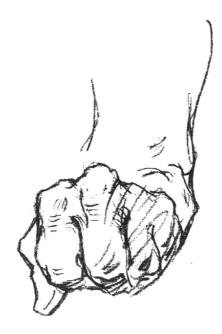

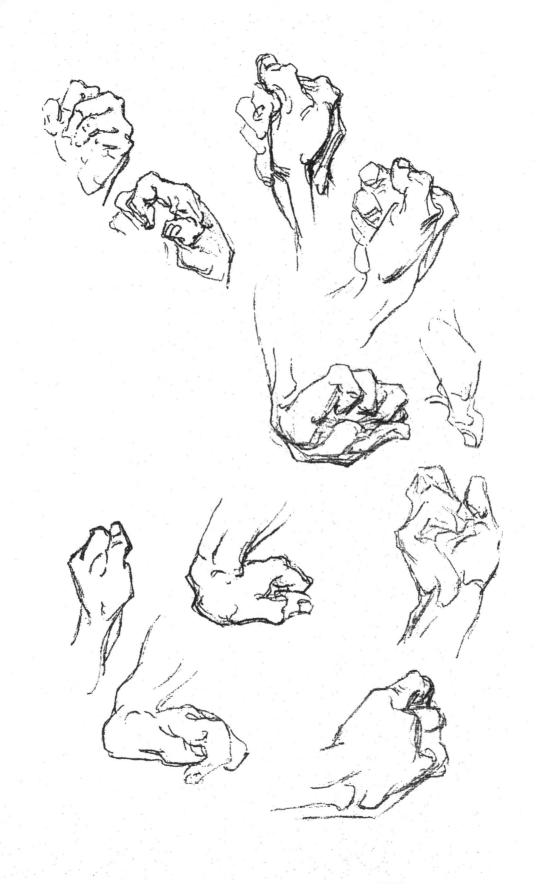

Mechanisms

❖

From practically the same foundation grew on the hind leg a foot, and on the fore limb a hand. The foot, standardized to conditions of pressure, has massive bones with short toes and huge heel; has arches, columns, etc.

In the hand the determining factors were suspension or clasping, and movement. As the mechanics requires, the bones are long and slender, the fingers are long and flexible, with suspensory tendons running their length inside (i. e., next the object clasped) ; and the strong opposing thumb is warped around forward to complete the circle. The heel of the hand is negligible. The wrist is tapering, to allow freedom of movement.

The line of tension from the arm passes through the radius, to the wrist, thence in straight line to the middle finger which is therefore the largest.

The thumb is warped around to the front corner of the wrist, covering at its base practically all of the side, and half of the front—the space opposite the bases of the first two fingers—and overlapping with its muscles the base of the third. Its attachment, in other words, is opposite the radius. It sweeps across the first three fingers.

The carpal bones are deeply arched backward across the wrist. This is to allow the flexor tendons to pass as near as possible to the point of least movement, in turning movements. Thus, in turning when the hand is clasped, there is little if any change of tension produced in these muscles by it.

From this point diverge the tendons to the fingers. This point is therefore the centre of symmetry

for the fingers. From it they radiate; around it the knuckles, rows of joints and finger tips form concentric arches; and when bent, the fingers form transverse arches. The centre of these arches is slightly drawn toward the base of the thumb by its power, and the finger arches are somewhat altered by crowding.

The ends of this wrist arch are its pillars—the trapezium under the thumb, the pisiform under the little finger side. The arch is a little higher and broader under the thumb, on account of the greater power applied there.

At the four corners of the wrist are attached muscles. But as the wrist bends back in clasping, the bases of the first and second fingers at the back are brought into more direct line with the tension; wherefore the muscle of this corner is doubled, and the bones are larger.

As the hand in clasping bends back and the thumb forward, the bones of the wrist adapt themselves. The bones of the second layer bend with the hand; those of the first layer remain straight with the wrist, although those under the thumb of both layers curve around with it.

Between these two layers is therefore an angle; it is seen in profile as a hook, pointing upward at the back. In extension (as in clasping), the radius is straight against the end of the hook. With the hand straight it is against a corner of it, leaving a step-down over the hook to the back of the hand. In flexion, the end of the hook seems to add itself to the end of the radius, making a long convex curve to the hollow of the hook, beyond which is the mound of the metacarpals, and beyond that again the somewhat hollowed sweep to the knuckles.

The wrist attaches to the radius, and therefore

this hook, with the prominent metacarpals, is oppo-
site the end of the radius—that is, a trifle to the
thumb side. They become a ridge which turns slight-
ly to follow the direction of the hand.

In its warping around, the thumb is not brought
to face the hand, but faces across the palm; in
position to bind down the ends of the fingers in
clasping. Being on the radial side, yet drawn toward
the mid line in traction, it makes the hand as a whole
bend more easily to the little finger or ulnar side.
Being in front, it causes the hand to bend more
easily backward.

MECHANISMS

Turning movement as distinguished from rotary movement (flexion to each corner in rotation) is not present in the wrist, but is produced by the radius or turning bone of the forearm. Movement in the wrist is confined to flexion and extension (about one right angle) and side-bending (a little more than half a right angle, in the average hand); these two combined produce some rotary movement.

In movements of the wrist to extreme positions, the hand and fingers almost always participate, on account of association of tendons and muscular action; and in these positions it is practically always separation and hooking of the fingers that is produced.

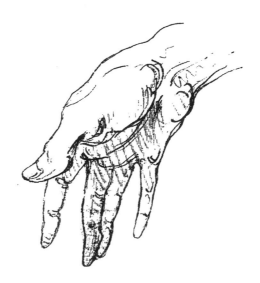

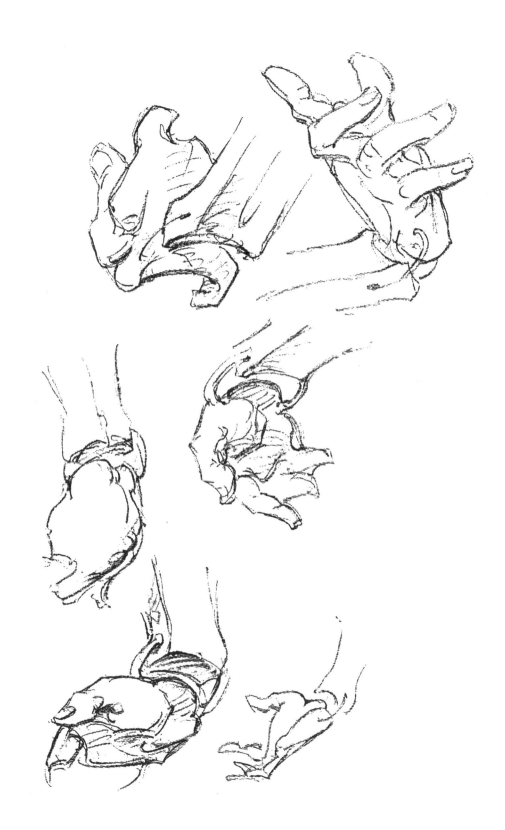

MECHANISMS

The movement of the hand reflects itself as far as the shoulder, through the biceps muscle, which aids in turning the radius. In all movement but turning, the wrist can act alone. Turning, to nearly two right angles, is carried out by the radius. Further movement of any kind must be performed by elbow or shoulder.

At the elbow it is the hinge movement that is important, wherefore the large size of the ulna or hinge bone, and the small size of the radius. At the wrist it is the turning movement that is important, wherefore the radius forms two-thirds of the joint, the ulna one-third.

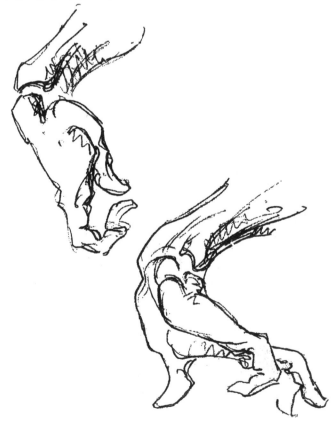

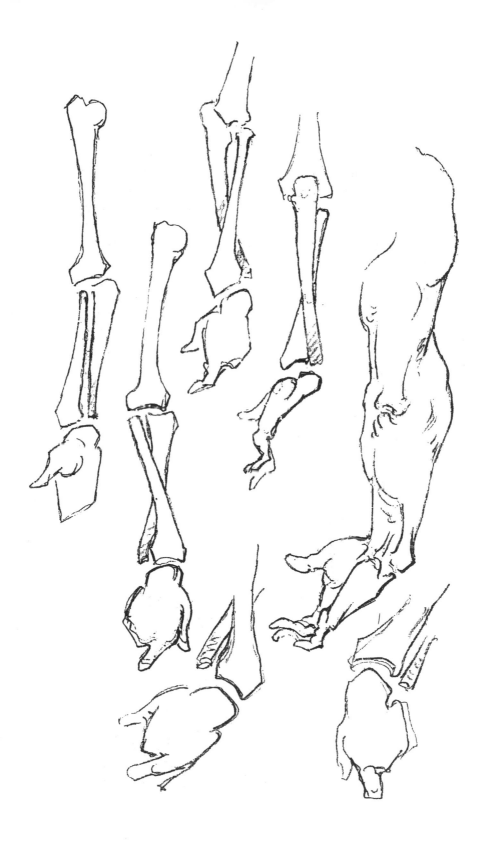

MECHANISMS

The two pillars of the wrist clasp the tendons almost like hooked fingers and thumb. The opening is closed by strong fascia into a ring through which these tendons pass. They are deeply placed so as to be as near as possible to the neutral point in turning the wrist, making unnecessary a readjustment of tension to the fingers when the wrist turns.

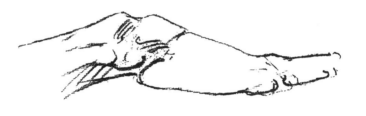

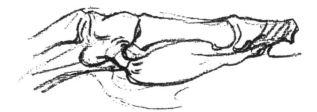

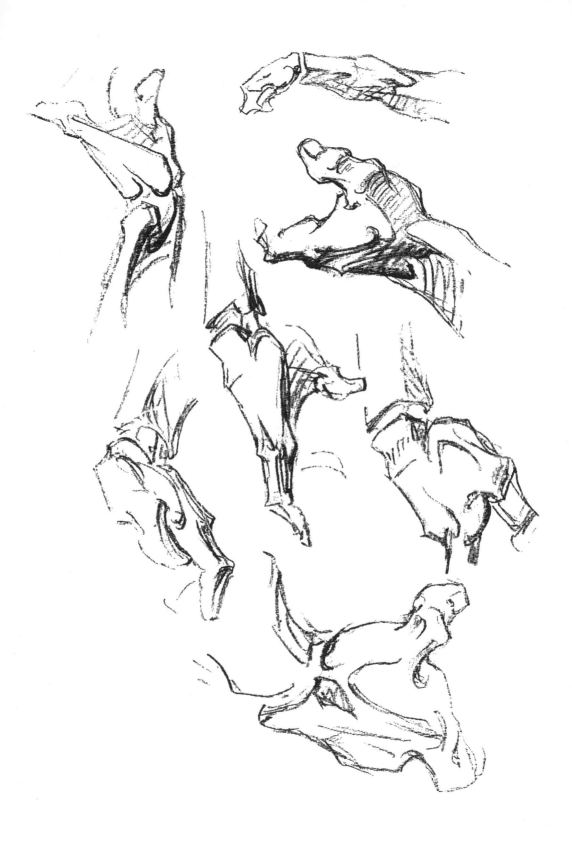

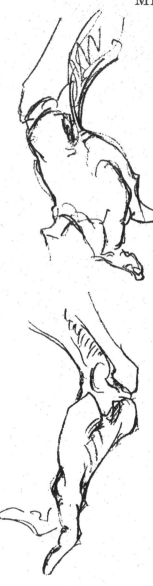

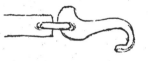

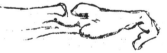

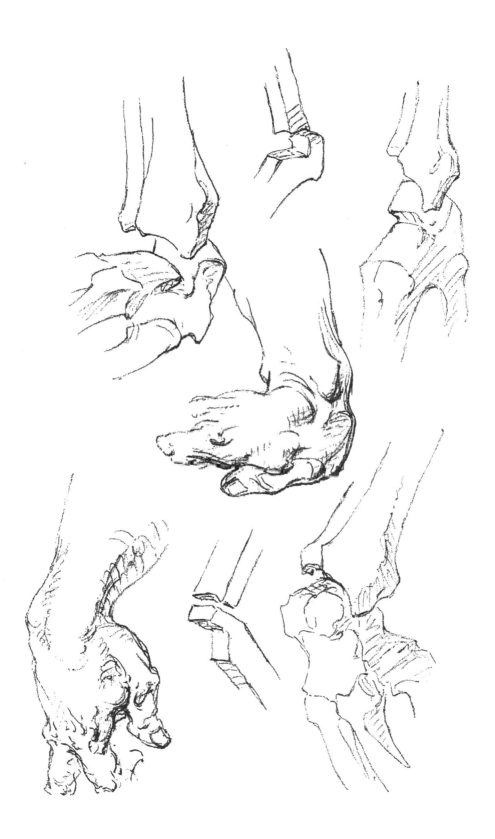

MECHANISMS

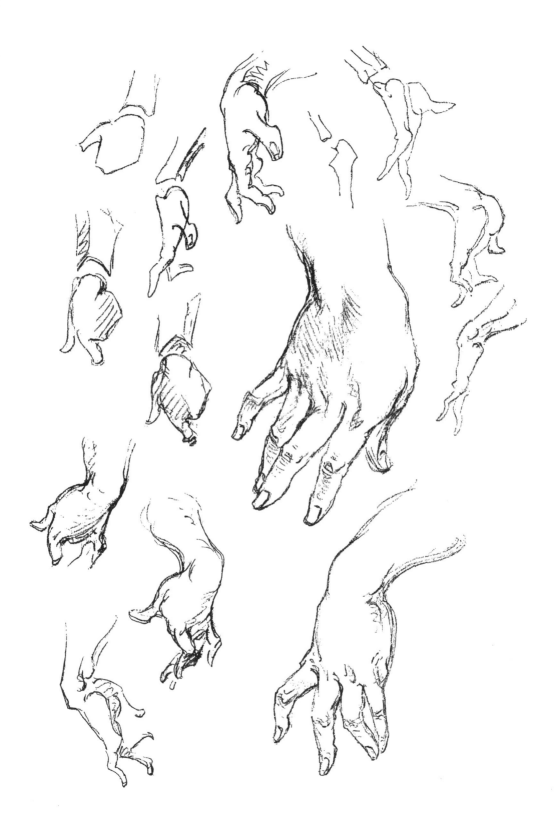

MECHANISMS

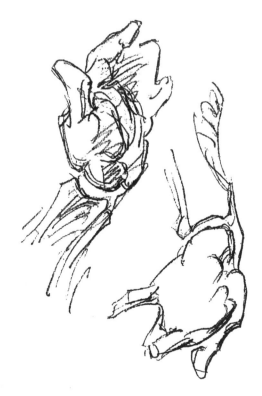

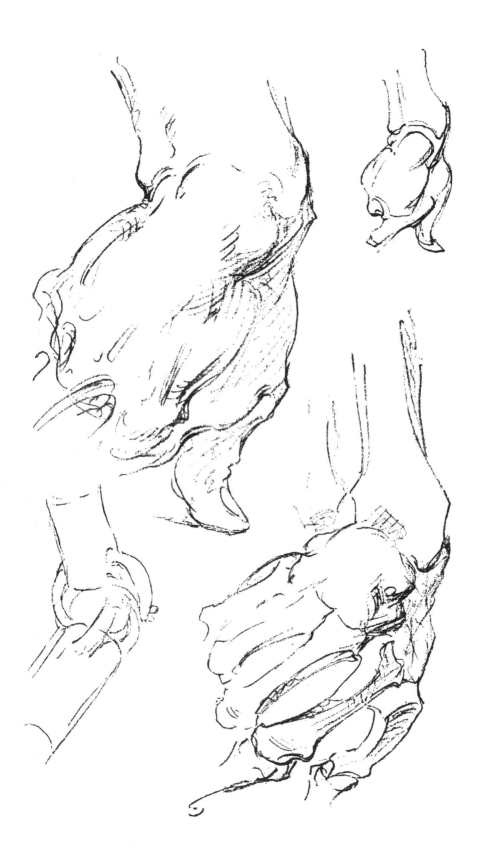

THE HAND

BONES OF THE WRIST, palm side:

1 Trapezium—No two sides parallel.
2 Trapezoid—Two sides parallel.
3 Os magnum—Great bone.
4 Unciform—Hook-like.
5 Scaphoid—Boat-shaped.
6 Semi-Lunar—Half-moon.
7 Cuneiform—Wedge-shaped.
8 Pisiform—Pea-shaped.

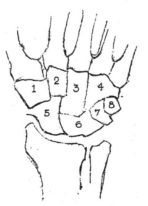

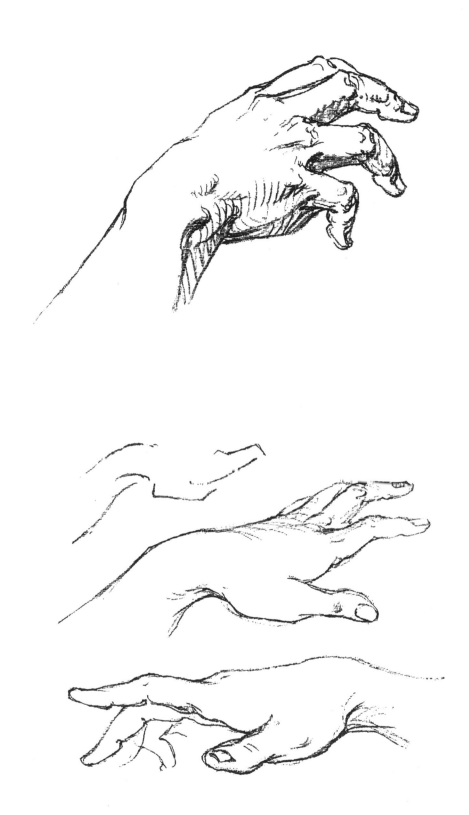

THE HAND

In the hand of the baby, neither anatomical nor mechanical features are in evidence, but are alike concealed under the soft flesh and smooth skin. In fact, neither anatomical nor mechanical features are sharply defined as yet; the bone is still partly cartilage, the joints still small, the muscles have not taken shape nor given shape to the skin.

The wrist is quite large in comparison with its size in mature hands, and the fingers quite short and symmetrically tapering in the same comparison. Instead of expanded joints we find constrictions in the flesh; instead of wrinkles over on the backs of knuckles and joints we find dimples. The wrist is marked by a double wrinkle. The first segment of the fingers, on account of the bulging and dimpling of the flesh, looks quite short. On the other hand, the middle joint of the thumb being, like the other joints, small, the last joint appears quite long, and the whole thumb has flowing lines.

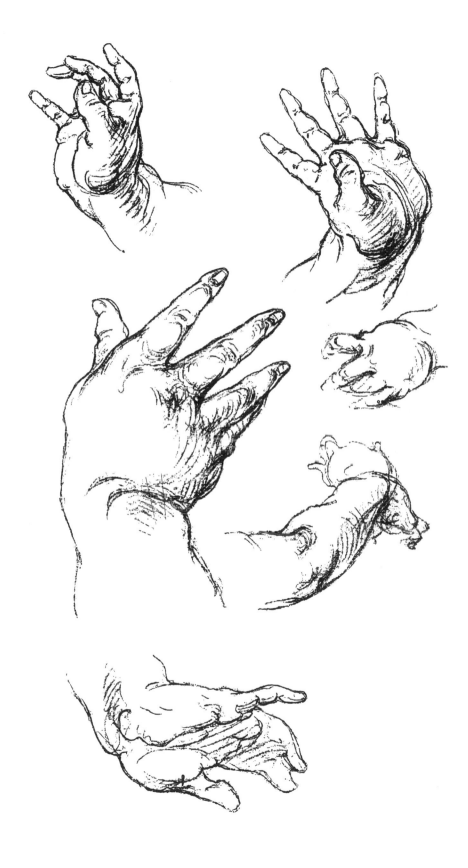

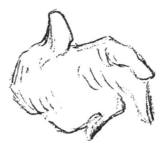

Origin, Insertion and Action
of Muscles

Origin, Insertion and Action
of Muscles

❖

THE HAND—Back View

ABDUCTOR MINIMI DIGITI: Draws little finger away from hand; from pisiform bone to first phalanx of little finger.

ABDUCTOR POLLICIS: Draws thumb from hand; from wrist bones and ligament, to first phalanx of thumb.

DORSAL INTEROSSEI: Between metacarpal bones, back side; from sides of metacarpals to bases of phalanges corresponding.

EXTENSOR BREVIS POLLICIS: Short extensor of thumb; from back of radius to base of first phalanx of thumb.

EXTENSOR CARPI ULNARIS: Extends wrist, ulnar side; from external condyle and ulna to base of fifth metacarpal.

EXTENSOR COMMUNIS DIGITORUM: Common extensor to all the fingers; from external condyle of humerus to all of second and third phalanges.

EXTENSOR CARPI RADIALIS BREVIOR; and

EXTENSOR CARPI RADIALIS LONGIOR: The long and short extensors of the wrist, radial side, representing the extensor that is doubled; from external condylar ridge of humerus to (5) base of second and third metacarpals, and (6) base of first metacarpal.

EXTENSOR LONGUS POLLICIS: Long extensor of thumb; from back of ulna to base of last phalanx of thumb.

EXTENSOR MINIMI DIGITI: Extends little finger; from external condyle of humerus to second and third phalanges of little finger.

EXTENSOR OSSIS METACARPI POLLICIS: Extensor of metacarpal bone (first segment) of thumb; from back of radius and ulna, to base of metacarpal bone of thumb.

Origin, Insertion and Action
of Muscles

❖

THE HAND—Palmar View

Abductor Minimi Digiti (see page 169).

Abductor Pollicis (see page 169).

Adductor Transversus Pollicis: Transverse (portion of) adductor muscle of thumb; from third metacarpal bone to first phalanx of thumb.

Annular Ligament of wrist; ligament that surrounds wrist like a bracelet; making with wrist arch a lesser ring for flexor tendons.

Flexor Brevis Minimi Digiti: Flexes little finger; from wrist bone and ligament to first phalanx of little finger.

Flexor Brevis Pollicis: Short flexor of thumb; from wrist bones and annular ligament and bases of first three metacarpals to first phalanx of thumb.

Flexor Carpi Radialis: Flexor of wrist, radial side; from internal condyle of humerus to metacarpal bone of index finger.

Flexor Carpi Ulnaris: Flexor of wrist, ulnar side; from internal condyle, olecranon and ulna to annular ligament, pisiform and fifth metacarpal bones.

Lumbricales: Fore and outer parts of each tendon of the flexor profundus, with the corresponding interossei.

OPPONENS POLLICIS: Draws thumb against fingers; from wrist bone and ligament to metacarpal bone of thumb.

PALMAR INTEROSSEI: Draw fingers together; from palmar surfaces of second, fourth and fifth metacarpal bones to bases of corresponding phalanges.

PALMARIS LONGUS: Long tensor of palmar fascia; from internal condyle to annular ligament and palmar fascia.

SUPINATOR LONGUS: Flexes and turns in radius and hand; from external condyloid ridge to tip of radius.

INDEX

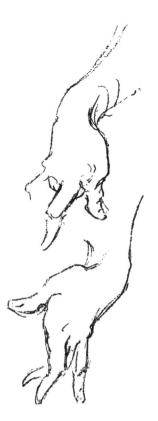

A CATALOG OF SELECTED
DOVER BOOKS
IN ALL FIELDS OF INTEREST

A CATALOG OF SELECTED DOVER
BOOKS IN ALL FIELDS OF INTEREST

100 BEST-LOVED POEMS, Edited by Philip Smith. "The Passionate Shepherd to His Love," "Shall I compare thee to a summer's day?" "Death, be not proud," "The Raven," "The Road Not Taken," plus works by Blake, Wordsworth, Byron, Shelley, Keats, many others. 96pp. 5‰ x 8¼. 0-486-28553-7

100 SMALL HOUSES OF THE THIRTIES, Brown-Blodgett Company. Exterior photographs and floor plans for 100 charming structures. Illustrations of models accompanied by descriptions of interiors, color schemes, closet space, and other amenities. 200 illustrations. 112pp. 8⅜ x 11. 0-486-44131-8

1000 TURN-OF-THE-CENTURY HOUSES: With Illustrations and Floor Plans, Herbert C. Chivers. Reproduced from a rare edition, this showcase of homes ranges from cottages and bungalows to sprawling mansions. Each house is meticulously illustrated and accompanied by complete floor plans. 256pp. 9⅜ x 12¼.

0-486-45596-3

101 GREAT AMERICAN POEMS, Edited by The American Poetry & Literacy Project. Rich treasury of verse from the 19th and 20th centuries includes works by Edgar Allan Poe, Robert Frost, Walt Whitman, Langston Hughes, Emily Dickinson, T. S. Eliot, other notables. 96pp. 5‰ x 8¼. 0-486-40158-8

101 GREAT SAMURAI PRINTS, Utagawa Kuniyoshi. Kuniyoshi was a master of the warrior woodblock print — and these 18th-century illustrations represent the pinnacle of his craft. Full-color portraits of renowned Japanese samurais pulse with movement, passion, and remarkably fine detail. 112pp. 8⅜ x 11. 0-486-46523-3

ABC OF BALLET, Janet Grosser. Clearly worded, abundantly illustrated little guide defines basic ballet-related terms: arabesque, battement, pas de chat, relevé, sissonne, many others. Pronunciation guide included. Excellent primer. 48pp. 4‰ x 5¾.

0-486-40871-X

ACCESSORIES OF DRESS: An Illustrated Encyclopedia, Katherine Lester and Bess Viola Oerke. Illustrations of hats, veils, wigs, cravats, shawls, shoes, gloves, and other accessories enhance an engaging commentary that reveals the humor and charm of the many-sided story of accessorized apparel. 644 figures and 59 plates. 608pp. 6⅛ x 9¼.

0-486-43378-1

ADVENTURES OF HUCKLEBERRY FINN, Mark Twain. Join Huck and Jim as their boyhood adventures along the Mississippi River lead them into a world of excitement, danger, and self-discovery. Humorous narrative, lyrical descriptions of the Mississippi valley, and memorable characters. 224pp. 5‰ x 8¼. 0-486-28061-6

ALICE STARMORE'S BOOK OF FAIR ISLE KNITTING, Alice Starmore. A noted designer from the region of Scotland's Fair Isle explores the history and techniques of this distinctive, stranded-color knitting style and provides copious illustrated instructions for 14 original knitwear designs. 208pp. 8⅜ x 10⅞. 0-486-47218-3

Browse over 9,000 books at www.doverpublications.com

ALICE'S ADVENTURES IN WONDERLAND, Lewis Carroll. Beloved classic about a little girl lost in a topsy-turvy land and her encounters with the White Rabbit, March Hare, Mad Hatter, Cheshire Cat, and other delightfully improbable characters. 42 illustrations by Sir John Tenniel. 96pp. 5⅜₆ x 8¼. 0-486-27543-4

AMERICA'S LIGHTHOUSES: An Illustrated History, Francis Ross Holland. Profusely illustrated fact-filled survey of American lighthouses since 1716. Over 200 stations — East, Gulf, and West coasts, Great Lakes, Hawaii, Alaska, Puerto Rico, the Virgin Islands, and the Mississippi and St. Lawrence Rivers. 240pp. 8 x 10¾.
0-486-25576-X

AN ENCYCLOPEDIA OF THE VIOLIN, Alberto Bachmann. Translated by Frederick H. Martens. Introduction by Eugene Ysaye. First published in 1925, this renowned reference remains unsurpassed as a source of essential information, from construction and evolution to repertoire and technique. Includes a glossary and 73 illustrations. 496pp. 6⅛ x 9¼. 0-486-46618-3

ANIMALS: 1,419 Copyright-Free Illustrations of Mammals, Birds, Fish, Insects, etc., Selected by Jim Harter. Selected for its visual impact and ease of use, this outstanding collection of wood engravings presents over 1,000 species of animals in extremely lifelike poses. Includes mammals, birds, reptiles, amphibians, fish, insects, and other invertebrates. 284pp. 9 x 12. 0-486-23766-4

THE ANNALS, Tacitus. Translated by Alfred John Church and William Jackson Brodribb. This vital chronicle of Imperial Rome, written by the era's great historian, spans A.D. 14-68 and paints incisive psychological portraits of major figures, from Tiberius to Nero. 416pp. 5⅜₆ x 8¼. 0-486-45236-0

ANTIGONE, Sophocles. Filled with passionate speeches and sensitive probing of moral and philosophical issues, this powerful and often-performed Greek drama reveals the grim fate that befalls the children of Oedipus. Footnotes. 64pp. 5⅜₆ x 8 ¼. 0-486-27804-2

ART DECO DECORATIVE PATTERNS IN FULL COLOR, Christian Stoll. Reprinted from a rare 1910 portfolio, 160 sensuous and exotic images depict a breathtaking array of florals, geometrics, and abstracts — all elegant in their stark simplicity. 64pp. 8⅜ x 11. 0-486-44862-2

THE ARTHUR RACKHAM TREASURY: 86 Full-Color Illustrations, Arthur Rackham. Selected and Edited by Jeff A. Menges. A stunning treasury of 86 full-page plates span the famed English artist's career, from *Rip Van Winkle* (1905) to masterworks such as *Undine, A Midsummer Night's Dream,* and *Wind in the Willows* (1939). 96pp. 8⅜ x 11.
0-486-44685-9

THE AUTHENTIC GILBERT & SULLIVAN SONGBOOK, W. S. Gilbert and A. S. Sullivan. The most comprehensive collection available, this songbook includes selections from every one of Gilbert and Sullivan's light operas. Ninety-two numbers are presented uncut and unedited, and in their original keys. 410pp. 9 x 12.
0-486-23482-7

THE AWAKENING, Kate Chopin. First published in 1899, this controversial novel of a New Orleans wife's search for love outside a stifling marriage shocked readers. Today, it remains a first-rate narrative with superb characterization. New introductory Note. 128pp. 5⅜₆ x 8¼. 0-486-27786-0

BASIC DRAWING, Louis Priscilla. Beginning with perspective, this commonsense manual progresses to the figure in movement, light and shade, anatomy, drapery, composition, trees and landscape, and outdoor sketching. Black-and-white illustrations throughout. 128pp. 8⅜ x 11. 0-486-45815-6

Browse over 9,000 books at www.doverpublications.com

THE BATTLES THAT CHANGED HISTORY, Fletcher Pratt. Historian profiles 16 crucial conflicts, ancient to modern, that changed the course of Western civilization. Gripping accounts of battles led by Alexander the Great, Joan of Arc, Ulysses S. Grant, other commanders. 27 maps. 352pp. 5⅜ x 8½. 0-486-41129-X

BEETHOVEN'S LETTERS, Ludwig van Beethoven. Edited by Dr. A. C. Kalischer. Features 457 letters to fellow musicians, friends, greats, patrons, and literary men. Reveals musical thoughts, quirks of personality, insights, and daily events. Includes 15 plates. 410pp. 5⅜ x 8½. 0-486-22769-3

BERNICE BOBS HER HAIR AND OTHER STORIES, F. Scott Fitzgerald. This brilliant anthology includes 6 of Fitzgerald's most popular stories: "The Diamond as Big as the Ritz," the title tale, "The Offshore Pirate," "The Ice Palace," "The Jelly Bean," and "May Day." 176pp. 5⅜ x 8½. 0-486-47049-0

BESLER'S BOOK OF FLOWERS AND PLANTS: 73 Full-Color Plates from Hortus Eystettensis, 1613, Basilius Besler. Here is a selection of magnificent plates from the *Hortus Eystettensis,* which vividly illustrated and identified the plants, flowers, and trees that thrived in the legendary German garden at Eichstätt. 80pp. 8⅜ x 11. 0-486-46005-3

THE BOOK OF KELLS, Edited by Blanche Cirker. Painstakingly reproduced from a rare facsimile edition, this volume contains full-page decorations, portraits, illustrations, plus a sampling of textual leaves with exquisite calligraphy and ornamentation. 32 full-color illustrations. 32pp. 9⅜ x 12¼. 0-486-24345-1

THE BOOK OF THE CROSSBOW: With an Additional Section on Catapults and Other Siege Engines, Ralph Payne-Gallwey. Fascinating study traces history and use of crossbow as military and sporting weapon, from Middle Ages to modern times. Also covers related weapons: balistas, catapults, Turkish bows, more. Over 240 illustrations. 400pp. 7¼ x 10⅛. 0-486-28720-3

THE BUNGALOW BOOK: Floor Plans and Photos of 112 Houses, 1910, Henry L. Wilson. Here are 112 of the most popular and economic blueprints of the early 20th century — plus an illustration or photograph of each completed house. A wonderful time capsule that still offers a wealth of valuable insights. 160pp. 8⅜ x 11. 0-486-45104-6

THE CALL OF THE WILD, Jack London. A classic novel of adventure, drawn from London's own experiences as a Klondike adventurer, relating the story of a heroic dog caught in the brutal life of the Alaska Gold Rush. Note. 64pp. 5³⁄₁₆ x 8¼. 0-486-26472-6

CANDIDE, Voltaire. Edited by Francois-Marie Arouet. One of the world's great satires since its first publication in 1759. Witty, caustic skewering of romance, science, philosophy, religion, government — nearly all human ideals and institutions. 112pp. 5³⁄₁₆ x 8¼. 0-486-26689-3

CELEBRATED IN THEIR TIME: Photographic Portraits from the George Grantham Bain Collection, Edited by Amy Pastan. With an Introduction by Michael Carlebach. Remarkable portrait gallery features 112 rare images of Albert Einstein, Charlie Chaplin, the Wright Brothers, Henry Ford, and other luminaries from the worlds of politics, art, entertainment, and industry. 128pp. 8⅜ x 11. 0-486-46754-6

CHARIOTS FOR APOLLO: The NASA History of Manned Lunar Spacecraft to 1969, Courtney G. Brooks, James M. Grimwood, and Loyd S. Swenson, Jr. This illustrated history by a trio of experts is the definitive reference on the Apollo spacecraft and lunar modules. It traces the vehicles' design, development, and operation in space. More than 100 photographs and illustrations. 576pp. 6¾ x 9¼. 0-486-46756-2

Browse over 9,000 books at www.doverpublications.com

A CHRISTMAS CAROL, Charles Dickens. This engrossing tale relates Ebenezer Scrooge's ghostly journeys through Christmases past, present, and future and his ultimate transformation from a harsh and grasping old miser to a charitable and compassionate human being. 80pp. 5³⁄₁₆ x 8¼. 0-486-26865-9

COMMON SENSE, Thomas Paine. First published in January of 1776, this highly influential landmark document clearly and persuasively argued for American separation from Great Britain and paved the way for the Declaration of Independence. 64pp. 5³⁄₁₆ x 8¼. 0-486-29602-4

THE COMPLETE SHORT STORIES OF OSCAR WILDE, Oscar Wilde. Complete texts of "The Happy Prince and Other Tales," "A House of Pomegranates," "Lord Arthur Savile's Crime and Other Stories," "Poems in Prose," and "The Portrait of Mr. W. H." 208pp. 5³⁄₁₆ x 8¼. 0-486-45216-6

COMPLETE SONNETS, William Shakespeare. Over 150 exquisite poems deal with love, friendship, the tyranny of time, beauty's evanescence, death, and other themes in language of remarkable power, precision, and beauty. Glossary of archaic terms. 80pp. 5³⁄₁₆ x 8¼. 0-486-26686-9

THE COUNT OF MONTE CRISTO: Abridged Edition, Alexandre Dumas. Falsely accused of treason, Edmond Dantès is imprisoned in the bleak Chateau d'If. After a hair-raising escape, he launches an elaborate plot to extract a bitter revenge against those who betrayed him. 448pp. 5³⁄₁₆ x 8¼. 0-486-45643-9

CRAFTSMAN BUNGALOWS: Designs from the Pacific Northwest, Yoho & Merritt. This reprint of a rare catalog, showcasing the charming simplicity and cozy style of Craftsman bungalows, is filled with photos of completed homes, plus floor plans and estimated costs. An indispensable resource for architects, historians, and illustrators. 112pp. 10 x 7. 0-486-46875-5

CRAFTSMAN BUNGALOWS: 59 Homes from "The Craftsman," Edited by Gustav Stickley. Best and most attractive designs from Arts and Crafts Movement publication — 1903-1916 — includes sketches, photographs of homes, floor plans, descriptive text. 128pp. 8¼ x 11. 0-486-25829-7

CRIME AND PUNISHMENT, Fyodor Dostoyevsky. Translated by Constance Garnett. Supreme masterpiece tells the story of Raskolnikov, a student tormented by his own thoughts after he murders an old woman. Overwhelmed by guilt and terror, he confesses and goes to prison. 480pp. 5³⁄₁₆ x 8¼. 0-486-41587-2

THE DECLARATION OF INDEPENDENCE AND OTHER GREAT DOCUMENTS OF AMERICAN HISTORY: 1775-1865, Edited by John Grafton. Thirteen compelling and influential documents: Henry's "Give Me Liberty or Give Me Death," Declaration of Independence, The Constitution, Washington's First Inaugural Address, The Monroe Doctrine, The Emancipation Proclamation, Gettysburg Address, more. 64pp. 5³⁄₁₆ x 8¼. 0-486-41124-9

THE DESERT AND THE SOWN: Travels in Palestine and Syria, Gertrude Bell. "The female Lawrence of Arabia," Gertrude Bell wrote captivating, perceptive accounts of her travels in the Middle East. This intriguing narrative, accompanied by 160 photos, traces her 1905 sojourn in Lebanon, Syria, and Palestine. 368pp. 5⅜ x 8½. 0-486-46876-3

A DOLL'S HOUSE, Henrik Ibsen. Ibsen's best-known play displays his genius for realistic prose drama. An expression of women's rights, the play climaxes when the central character, Nora, rejects a smothering marriage and life in "a doll's house." 80pp. 5³⁄₁₆ x 8¼. 0-486-27062-9

DOOMED SHIPS: Great Ocean Liner Disasters, William H. Miller, Jr. Nearly 200 photographs, many from private collections, highlight tales of some of the vessels whose pleasure cruises ended in catastrophe: the *Morro Castle, Normandie, Andrea Doria, Europa,* and many others. 128pp. 8⅞ x 11¼. 0-486-45366-9

THE DORÉ BIBLE ILLUSTRATIONS, Gustave Doré. Detailed plates from the Bible: the Creation scenes, Adam and Eve, horrifying visions of the Flood, the battle sequences with their monumental crowds, depictions of the life of Jesus, 241 plates in all. 241pp. 9 x 12. 0-486-23004-X

DRAWING DRAPERY FROM HEAD TO TOE, Cliff Young. Expert guidance on how to draw shirts, pants, skirts, gloves, hats, and coats on the human figure, including folds in relation to the body, pull and crush, action folds, creases, more. Over 200 drawings. 48pp. 8¼ x 11. 0-486-45591-2

DUBLINERS, James Joyce. A fine and accessible introduction to the work of one of the 20th century's most influential writers, this collection features 15 tales, including a masterpiece of the short-story genre, "The Dead." 160pp. 5³⁄₁₆ x 8¼. 0-486-26870-5

EASY-TO-MAKE POP-UPS, Joan Irvine. Illustrated by Barbara Reid. Dozens of wonderful ideas for three-dimensional paper fun — from holiday greeting cards with moving parts to a pop-up menagerie. Easy-to-follow, illustrated instructions for more than 30 projects. 299 black-and-white illustrations. 96pp. 8⅜ x 11. 0-486-44622-0

EASY-TO-MAKE STORYBOOK DOLLS: A "Novel" Approach to Cloth Dollmaking, Sherralyn St. Clair. Favorite fictional characters come alive in this unique beginner's dollmaking guide. Includes patterns for Pollyanna, Dorothy from *The Wonderful Wizard of Oz,* Mary of *The Secret Garden,* plus easy-to-follow instructions, 263 black-and-white illustrations, and an 8-page color insert. 112pp. 8¼ x 11. 0-486-47360-0

EINSTEIN'S ESSAYS IN SCIENCE, Albert Einstein. Speeches and essays in accessible, everyday language profile influential physicists such as Niels Bohr and Isaac Newton. They also explore areas of physics to which the author made major contributions. 128pp. 5 x 8. 0-486-47011-3

EL DORADO: Further Adventures of the Scarlet Pimpernel, Baroness Orczy. A popular sequel to *The Scarlet Pimpernel,* this suspenseful story recounts the Pimpernel's attempts to rescue the Dauphin from imprisonment during the French Revolution. An irresistible blend of intrigue, period detail, and vibrant characterizations. 352pp. 5³⁄₁₆ x 8¼. 0-486-44026-5

ELEGANT SMALL HOMES OF THE TWENTIES: 99 Designs from a Competition, Chicago Tribune. Nearly 100 designs for five- and six-room houses feature New England and Southern colonials, Normandy cottages, stately Italianate dwellings, and other fascinating snapshots of American domestic architecture of the 1920s. 112pp. 9 x 12. 0-486-46910-7

THE ELEMENTS OF STYLE: The Original Edition, William Strunk, Jr. This is the book that generations of writers have relied upon for timeless advice on grammar, diction, syntax, and other essentials. In concise terms, it identifies the principal requirements of proper style and common errors. 64pp. 5⅜ x 8½. 0-486-44798-7

THE ELUSIVE PIMPERNEL, Baroness Orczy. Robespierre's revolutionaries find their wicked schemes thwarted by the heroic Pimpernel — Sir Percival Blakeney. In this thrilling sequel, Chauvelin devises a plot to eliminate the Pimpernel and his wife. 272pp. 5³⁄₁₆ x 8¼. 0-486-45464-9

AN ENCYCLOPEDIA OF BATTLES: Accounts of Over 1,560 Battles from 1479 B.C. to the Present, David Eggenberger. Essential details of every major battle in recorded history from the first battle of Megiddo in 1479 B.C. to Grenada in 1984. List of battle maps. 99 illustrations. 544pp. 6½ x 9¼. 0-486-24913-1

ENCYCLOPEDIA OF EMBROIDERY STITCHES, INCLUDING CREWEL, Marion Nichols. Precise explanations and instructions, clearly illustrated, on how to work chain, back, cross, knotted, woven stitches, and many more — 178 in all, including Cable Outline, Whipped Satin, and Eyelet Buttonhole. Over 1400 illustrations. 219pp. 8⅜ x 11¼. 0-486-22929-7

ENTER JEEVES: 15 Early Stories, P. G. Wodehouse. Splendid collection contains first 8 stories featuring Bertie Wooster, the deliciously dim aristocrat and Jeeves, his brainy, imperturbable manservant. Also, the complete Reggie Pepper (Bertie's prototype) series. 288pp. 5⅜ x 8½. 0-486-29717-9

ERIC SLOANE'S AMERICA: Paintings in Oil, Michael Wigley. With a Foreword by Mimi Sloane. Eric Sloane's evocative oils of America's landscape and material culture shimmer with immense historical and nostalgic appeal. This original hardcover collection gathers nearly a hundred of his finest paintings, with subjects ranging from New England to the American Southwest. 128pp. 10⅜ x 9.

0-486-46525-X

ETHAN FROME, Edith Wharton. Classic story of wasted lives, set against a bleak New England background. Superbly delineated characters in a hauntingly grim tale of thwarted love. Considered by many to be Wharton's masterpiece. 96pp. 5³⁄₁₆ x 8 ¼.

0-486-26690-7

THE EVERLASTING MAN, G. K. Chesterton. Chesterton's view of Christianity — as a blend of philosophy and mythology, satisfying intellect and spirit — applies to his brilliant book, which appeals to readers' heads as well as their hearts. 288pp. 5⅜ x 8½.

0-486-46036-3

THE FIELD AND FOREST HANDY BOOK, Daniel Beard. Written by a co-founder of the Boy Scouts, this appealing guide offers illustrated instructions for building kites, birdhouses, boats, igloos, and other fun projects, plus numerous helpful tips for campers. 448pp. 5³⁄₁₆ x 8¼. 0-486-46191-2

FINDING YOUR WAY WITHOUT MAP OR COMPASS, Harold Gatty. Useful, instructive manual shows would-be explorers, hikers, bikers, scouts, sailors, and survivalists how to find their way outdoors by observing animals, weather patterns, shifting sands, and other elements of nature. 288pp. 5⅜ x 8½. 0-486-40613-X

FIRST FRENCH READER: A Beginner's Dual-Language Book, Edited and Translated by Stanley Appelbaum. This anthology introduces 50 legendary writers — Voltaire, Balzac, Baudelaire, Proust, more — through passages from The Red and the Black, Les Misérables, Madame Bovary, and other classics. Original French text plus English translation on facing pages. 240pp. 5⅜ x 8½. 0-486-46178-5

FIRST GERMAN READER: A Beginner's Dual-Language Book, Edited by Harry Steinhauer. Specially chosen for their power to evoke German life and culture, these short, simple readings include poems, stories, essays, and anecdotes by Goethe, Hesse, Heine, Schiller, and others. 224pp. 5⅜ x 8½. 0-486-46179-3

FIRST SPANISH READER: A Beginner's Dual-Language Book, Angel Flores. Delightful stories, other material based on works of Don Juan Manuel, Luis Taboada, Ricardo Palma, other noted writers. Complete faithful English translations on facing pages. Exercises. 176pp. 5⅜ x 8½. 0-486-25810-6

FIVE ACRES AND INDEPENDENCE, Maurice G. Kains. Great back-to-the-land classic explains basics of self-sufficient farming. The one book to get. 95 illustrations. 397pp. 5⅜ x 8½. 0-486-20974-1

FLAGG'S SMALL HOUSES: Their Economic Design and Construction, 1922, Ernest Flagg. Although most famous for his skyscrapers, Flagg was also a proponent of the well-designed single-family dwelling. His classic treatise features innovations that save space, materials, and cost. 526 illustrations. 160pp. 9⅜ x 12¼.

0-486-45197-6

FLATLAND: A Romance of Many Dimensions, Edwin A. Abbott. Classic of science (and mathematical) fiction — charmingly illustrated by the author — describes the adventures of A. Square, a resident of Flatland, in Spaceland (three dimensions), Lineland (one dimension), and Pointland (no dimensions). 96pp. 5³⁄₁₆ x 8¼.

0-486-27263-X

FRANKENSTEIN, Mary Shelley. The story of Victor Frankenstein's monstrous creation and the havoc it caused has enthralled generations of readers and inspired countless writers of horror and suspense. With the author's own 1831 introduction. 176pp. 5³⁄₁₆ x 8¼. 0-486-28211-2

THE GARGOYLE BOOK: 572 Examples from Gothic Architecture, Lester Burbank Bridaham. Dispelling the conventional wisdom that French Gothic architectural flourishes were born of despair or gloom, Bridaham reveals the whimsical nature of these creations and the ingenious artisans who made them. 572 illustrations. 224pp. 8⅜ x 11. 0-486-44754-5

THE GIFT OF THE MAGI AND OTHER SHORT STORIES, O. Henry. Sixteen captivating stories by one of America's most popular storytellers. Included are such classics as "The Gift of the Magi," "The Last Leaf," and "The Ransom of Red Chief." Publisher's Note. 96pp. 5³⁄₁₆ x 8¼. 0-486-27061-0

THE GOETHE TREASURY: Selected Prose and Poetry, Johann Wolfgang von Goethe. Edited, Selected, and with an Introduction by Thomas Mann. In addition to his lyric poetry, Goethe wrote travel sketches, autobiographical studies, essays, letters, and proverbs in rhyme and prose. This collection presents outstanding examples from each genre. 368pp. 5⅜ x 8½. 0-486-44780-4

GREAT EXPECTATIONS, Charles Dickens. Orphaned Pip is apprenticed to the dirty work of the forge but dreams of becoming a gentleman — and one day finds himself in possession of "great expectations." Dickens' finest novel. 400pp. 5³⁄₁₆ x 8¼.

0-486-41586-4

GREAT WRITERS ON THE ART OF FICTION: From Mark Twain to Joyce Carol Oates, Edited by James Daley. An indispensable source of advice and inspiration, this anthology features essays by Henry James, Kate Chopin, Willa Cather, Sinclair Lewis, Jack London, Raymond Chandler, Raymond Carver, Eudora Welty, and Kurt Vonnegut, Jr. 192pp. 5⅜ x 8½. 0-486-45128-3

HAMLET, William Shakespeare. The quintessential Shakespearean tragedy, whose highly charged confrontations and anguished soliloquies probe depths of human feeling rarely sounded in any art. Reprinted from an authoritative British edition complete with illuminating footnotes. 128pp. 5³⁄₁₆ x 8¼. 0-486-27278-8

THE HAUNTED HOUSE, Charles Dickens. A Yuletide gathering in an eerie country retreat provides the backdrop for Dickens and his friends — including Elizabeth Gaskell and Wilkie Collins — who take turns spinning supernatural yarns. 144pp. 5⅜ x 8½. 0-486-46309-5

HEART OF DARKNESS, Joseph Conrad. Dark allegory of a journey up the Congo River and the narrator's encounter with the mysterious Mr. Kurtz. Masterly blend of adventure, character study, psychological penetration. For many, Conrad's finest, most enigmatic story. 80pp. 5⅜ x 8¼. 0-486-26464-5

HENSON AT THE NORTH POLE, Matthew A. Henson. This thrilling memoir by the heroic African-American who was Peary's companion through two decades of Arctic exploration recounts a tale of danger, courage, and determination. "Fascinating and exciting." — *Commonweal.* 128pp. 5⅜ x 8½. 0-486-45472-X

HISTORIC COSTUMES AND HOW TO MAKE THEM, Mary Fernald and E. Shenton. Practical, informative guidebook shows how to create everything from short tunics worn by Saxon men in the fifth century to a lady's bustle dress of the late 1800s. 81 illustrations. 176pp. 5⅜ x 8½. 0-486-44906-8

THE HOUND OF THE BASKERVILLES, Arthur Conan Doyle. A deadly curse in the form of a legendary ferocious beast continues to claim its victims from the Baskerville family until Holmes and Watson intervene. Often called the best detective story ever written. 128pp. 5⅜₁₆ x 8¼. 0-486-28214-7

THE HOUSE BEHIND THE CEDARS, Charles W. Chesnutt. Originally published in 1900, this groundbreaking novel by a distinguished African American author recounts the drama of a brother and sister who "pass for white" during the dangerous days of Reconstruction. 208pp. 5⅜ x 8½. 0-486-46144-0

THE HUMAN FIGURE IN MOTION, Eadweard Muybridge. The 4,789 photographs in this definitive selection show the human figure — models almost all undraped — engaged in over 160 different types of action: running, climbing stairs, etc. 390pp. 7⅞ x 10⅝. 0-486-20204-6

THE IMPORTANCE OF BEING EARNEST, Oscar Wilde. Wilde's witty and buoyant comedy of manners, filled with some of literature's most famous epigrams, reprinted from an authoritative British edition. Considered Wilde's most perfect work. 64pp. 5⅜₁₆ x 8¼. 0-486-26478-5

THE INFERNO, Dante Alighieri. Translated and with notes by Henry Wadsworth Longfellow. The first stop on Dante's famous journey from Hell to Purgatory to Paradise, this 14th-century allegorical poem blends vivid and shocking imagery with graceful lyricism. Translated by the beloved 19th-century poet, Henry Wadsworth Longfellow. 256pp. 5⅜₁₆ x 8¼. 0-486-44288-8

JANE EYRE, Charlotte Brontë. Written in 1847, *Jane Eyre* tells the tale of an orphan girl's progress from the custody of cruel relatives to an oppressive boarding school and its culmination in a troubled career as a governess. 448pp. 5⅜₁₆ x 8¼.
0-486-42449-9

JAPANESE WOODBLOCK FLOWER PRINTS, Tanigami Kônan. Extraordinary collection of Japanese woodblock prints by a well-known artist features 120 plates in brilliant color. Realistic images from a rare edition include daffodils, tulips, and other familiar and unusual flowers. 128pp. 11 x 8¼. 0-486-46442-3

JEWELRY MAKING AND DESIGN, Augustus F. Rose and Antonio Cirino. Professional secrets of jewelry making are revealed in a thorough, practical guide. Over 200 illustrations. 306pp. 5⅜ x 8½. 0-486-21750-7

JULIUS CAESAR, William Shakespeare. Great tragedy based on Plutarch's account of the lives of Brutus, Julius Caesar and Mark Antony. Evil plotting, ringing oratory, high tragedy with Shakespeare's incomparable insight, dramatic power. Explanatory footnotes. 96pp. 5⅜₁₆ x 8¼. 0-486-26876-4

Browse over 9,000 books at www.doverpublications.com

THE JUNGLE, Upton Sinclair. 1906 bestseller shockingly reveals intolerable labor practices and working conditions in the Chicago stockyards as it tells the grim story of a Slavic family that emigrates to America full of optimism but soon faces despair. 320pp. 5³⁄₁₆ x 8¼. 0-486-41923-1

THE KINGDOM OF GOD IS WITHIN YOU, Leo Tolstoy. The soul-searching book that inspired Gandhi to embrace the concept of passive resistance, Tolstoy's 1894 polemic clearly outlines a radical, well-reasoned revision of traditional Christian thinking. 352pp. 5³⁄₁₆ x 8¼. 0-486-45138-0

THE LADY OR THE TIGER?: and Other Logic Puzzles, Raymond M. Smullyan. Created by a renowned puzzle master, these whimsically themed challenges involve paradoxes about probability, time, and change; metapuzzles; and self-referentiality. Nineteen chapters advance in difficulty from relatively simple to highly complex. 1982 edition. 240pp. 5⅜ x 8½. 0-486-47027-X

LEAVES OF GRASS: The Original 1855 Edition, Walt Whitman. Whitman's immortal collection includes some of the greatest poems of modern times, including his masterpiece, "Song of Myself." Shattering standard conventions, it stands as an unabashed celebration of body and nature. 128pp. 5³⁄₁₆ x 8¼. 0-486-45676-5

LES MISÉRABLES, Victor Hugo. Translated by Charles E. Wilbour. Abridged by James K. Robinson. A convict's heroic struggle for justice and redemption plays out against a fiery backdrop of the Napoleonic wars. This edition features the excellent original translation and a sensitive abridgment. 304pp. 6⅛ x 9¼.
0-486-45789-3

LILITH: A Romance, George MacDonald. In this novel by the father of fantasy literature, a man travels through time to meet Adam and Eve and to explore humanity's fall from grace and ultimate redemption. 240pp. 5⅜ x 8½.
0-486-46818-6

THE LOST LANGUAGE OF SYMBOLISM, Harold Bayley. This remarkable book reveals the hidden meaning behind familiar images and words, from the origins of Santa Claus to the fleur-de-lys, drawing from mythology, folklore, religious texts, and fairy tales. 1,418 illustrations. 784pp. 5⅜ x 8½. 0-486-44787-1

MACBETH, William Shakespeare. A Scottish nobleman murders the king in order to succeed to the throne. Tortured by his conscience and fearful of discovery, he becomes tangled in a web of treachery and deceit that ultimately spells his doom. 96pp. 5³⁄₁₆ x 8¼. 0-486-27802-6

MAKING AUTHENTIC CRAFTSMAN FURNITURE: Instructions and Plans for 62 Projects, Gustav Stickley. Make authentic reproductions of handsome, functional, durable furniture: tables, chairs, wall cabinets, desks, a hall tree, and more. Construction plans with drawings, schematics, dimensions, and lumber specs reprinted from 1900s *The Craftsman* magazine. 128pp. 8¼ x 11. 0-486-25000-8

MATHEMATICS FOR THE NONMATHEMATICIAN, Morris Kline. Erudite and entertaining overview follows development of mathematics from ancient Greeks to present. Topics include logic and mathematics, the fundamental concept, differential calculus, probability theory, much more. Exercises and problems. 641pp. 5⅜ x 8½. 0-486-24823-2

MEMOIRS OF AN ARABIAN PRINCESS FROM ZANZIBAR, Emily Ruete. This 19th-century autobiography offers a rare inside look at the society surrounding a sultan's palace. A real-life princess in exile recalls her vanished world of harems, slave trading, and court intrigues. 288pp. 5⅜ x 8½. 0-486-47121-7

Browse over 9,000 books at www.doverpublications.com

THE METAMORPHOSIS AND OTHER STORIES, Franz Kafka. Excellent new English translations of title story (considered by many critics Kafka's most perfect work), plus "The Judgment," "In the Penal Colony," "A Country Doctor," and "A Report to an Academy." Note. 96pp. 5³⁄₁₆ x 8¼. 0-486-29030-1

MICROSCOPIC ART FORMS FROM THE PLANT WORLD, R. Anheisser. From undulating curves to complex geometrics, a world of fascinating images abound in this classic, illustrated survey of microscopic plants. Features 400 detailed illustrations of nature's minute but magnificent handiwork. The accompanying CD-ROM includes all of the images in the book. 128pp. 9 x 9. 0-486-46013-4

A MIDSUMMER NIGHT'S DREAM, William Shakespeare. Among the most popular of Shakespeare's comedies, this enchanting play humorously celebrates the vagaries of love as it focuses upon the intertwined romances of several pairs of lovers. Explanatory footnotes. 80pp. 5³⁄₁₆ x 8¼. 0-486-27067-X

THE MONEY CHANGERS, Upton Sinclair. Originally published in 1908, this cautionary novel from the author of *The Jungle* explores corruption within the American system as a group of power brokers joins forces for personal gain, triggering a crash on Wall Street 192pp. 5⅜ x 8½. 0-486-46917-1

THE MOST POPULAR HOMES OF THE TWENTIES, William A. Radford. With a New Introduction by Daniel D. Reiff. Based on a rare 1925 catalog, this architectural showcase features floor plans, construction details, and photos of 26 homes, plus articles on entrances, porches, garages, and more. 250 illustrations, 21 color plates. 176pp. 8⅜ x 11. 0-486-47028-8

MY 66 YEARS IN THE BIG LEAGUES, Connie Mack. With a New Introduction by Rich Westcott. A Founding Father of modern baseball, Mack holds the record for most wins — and losses — by a major league manager. Enhanced by 70 photographs, his warmhearted autobiography is populated by many legends of the game. 288pp. 5⅜ x 8½. 0-486-47184-5

NARRATIVE OF THE LIFE OF FREDERICK DOUGLASS, Frederick Douglass. Douglass's graphic depictions of slavery, harrowing escape to freedom, and life as a newspaper editor, eloquent orator, and impassioned abolitionist. 96pp. 5³⁄₁₆ x 8¼. 0-486-28499-9

THE NIGHTLESS CITY: Geisha and Courtesan Life in Old Tokyo, J. E. de Becker. This unsurpassed study from 100 years ago ventured into Tokyo's red-light district to survey geisha and courtesan life and offer meticulous descriptions of training, dress, social hierarchy, and erotic practices. 49 black-and-white illustrations; 2 maps. 496pp. 5⅜ x 8½. 0-486-45563-7

THE ODYSSEY, Homer. Excellent prose translation of ancient epic recounts adventures of the homeward-bound Odysseus. Fantastic cast of gods, giants, cannibals, sirens, other supernatural creatures — true classic of Western literature. 256pp. 5³⁄₁₆ x 8¼. 0-486-40654-7

OEDIPUS REX, Sophocles. Landmark of Western drama concerns the catastrophe that ensues when King Oedipus discovers he has inadvertently killed his father and married his mother. Masterly construction, dramatic irony. Explanatory footnotes. 64pp. 5³⁄₁₆ x 8¼. 0-486-26877-2

ONCE UPON A TIME: The Way America Was, Eric Sloane. Nostalgic text and drawings brim with gentle philosophies and descriptions of how we used to live — self-sufficiently — on the land, in homes, and among the things built by hand. 44 line illustrations. 64pp. 8⅜ x 11. 0-486-44411-2

ONE OF OURS, Willa Cather. The Pulitzer Prize–winning novel about a young Nebraskan looking for something to believe in. Alienated from his parents, rejected by his wife, he finds his destiny on the bloody battlefields of World War I. 352pp. 5³⁄₁₆ x 8¼. 0-486-45599-8

ORIGAMI YOU CAN USE: 27 Practical Projects, Rick Beech. Origami models can be more than decorative, and this unique volume shows how! The 27 practical projects include a CD case, frame, napkin ring, and dish. Easy instructions feature 400 two-color illustrations. 96pp. 8¼ x 11. 0-486-47057-1

OTHELLO, William Shakespeare. Towering tragedy tells the story of a Moorish general who earns the enmity of his ensign Iago when he passes him over for a promotion. Masterly portrait of an archvillain. Explanatory footnotes. 112pp. 5³⁄₁₆ x 8¼.
0-486-29097-2

PARADISE LOST, John Milton. Notes by John A. Himes. First published in 1667, *Paradise Lost* ranks among the greatest of English literature's epic poems. It's a sublime retelling of Adam and Eve's fall from grace and expulsion from Eden. Notes by John A. Himes. 480pp. 5³⁄₁₆ x 8¼. 0-486-44287-X

PASSING, Nella Larsen. Married to a successful physician and prominently ensconced in society, Irene Redfield leads a charmed existence — until a chance encounter with a childhood friend who has been "passing for white." 112pp. 5⅜ x 8½. 0-486-43713-2

PERSPECTIVE DRAWING FOR BEGINNERS, Len A. Doust. Doust carefully explains the roles of lines, boxes, and circles, and shows how visualizing shapes and forms can be used in accurate depictions of perspective. One of the most concise introductions available. 33 illustrations. 64pp. 5⅜ x 8½. 0-486-45149-6

PERSPECTIVE MADE EASY, Ernest R. Norling. Perspective is easy; yet, surprisingly few artists know the simple rules that make it so. Remedy that situation with this simple, step-by-step book, the first devoted entirely to the topic. 256 illustrations. 224pp. 5⅜ x 8½. 0-486-40473-0

THE PICTURE OF DORIAN GRAY, Oscar Wilde. Celebrated novel involves a handsome young Londoner who sinks into a life of depravity. His body retains perfect youth and vigor while his recent portrait reflects the ravages of his crime and sensuality. 176pp. 5³⁄₁₆ x 8¼. 0-486-27807-7

PRIDE AND PREJUDICE, Jane Austen. One of the most universally loved and admired English novels, an effervescent tale of rural romance transformed by Jane Austen's art into a witty, shrewdly observed satire of English country life. 272pp. 5³⁄₁₆ x 8¼.
0-486-28473-5

THE PRINCE, Niccolò Machiavelli. Classic, Renaissance-era guide to acquiring and maintaining political power. Today, nearly 500 years after it was written, this calculating prescription for autocratic rule continues to be much read and studied. 80pp. 5³⁄₁₆ x 8¼. 0-486-27274-5

QUICK SKETCHING, Carl Cheek. A perfect introduction to the technique of "quick sketching." Drawing upon an artist's immediate emotional responses, this is an extremely effective means of capturing the essential form and features of a subject. More than 100 black-and-white illustrations throughout. 48pp. 11 x 8¼.
0-486-46608-6

RANCH LIFE AND THE HUNTING TRAIL, Theodore Roosevelt. Illustrated by Frederic Remington. Beautifully illustrated by Remington, Roosevelt's celebration of the Old West recounts his adventures in the Dakota Badlands of the 1880s, from roundups to Indian encounters to hunting bighorn sheep. 208pp. 6¼ x 9¼. 0-486-47340-6

THE RED BADGE OF COURAGE, Stephen Crane. Amid the nightmarish chaos of a Civil War battle, a young soldier discovers courage, humility, and, perhaps, wisdom. Uncanny re-creation of actual combat. Enduring landmark of American fiction. 112pp. 5³⁄₁₆ x 8¼. 0-486-26465-3

RELATIVITY SIMPLY EXPLAINED, Martin Gardner. One of the subject's clearest, most entertaining introductions offers lucid explanations of special and general theories of relativity, gravity, and spacetime, models of the universe, and more. 100 illustrations. 224pp. 5⅜ x 8½. 0-486-29315-7

REMBRANDT DRAWINGS: 116 Masterpieces in Original Color, Rembrandt van Rijn. This deluxe hardcover edition features drawings from throughout the Dutch master's prolific career. Informative captions accompany these beautifully reproduced landscapes, biblical vignettes, figure studies, animal sketches, and portraits. 128pp. 8⅜ x 11. 0-486-46149-1

THE ROAD NOT TAKEN AND OTHER POEMS, Robert Frost. A treasury of Frost's most expressive verse. In addition to the title poem: "An Old Man's Winter Night," "In the Home Stretch," "Meeting and Passing," "Putting in the Seed," many more. All complete and unabridged. 64pp. 5³⁄₁₆ x 8¼. 0-486-27550-7

ROMEO AND JULIET, William Shakespeare. Tragic tale of star-crossed lovers, feuding families and timeless passion contains some of Shakespeare's most beautiful and lyrical love poetry. Complete, unabridged text with explanatory footnotes. 96pp. 5³⁄₁₆ x 8¼. 0-486-27557-4

SANDITON AND THE WATSONS: Austen's Unfinished Novels, Jane Austen. Two tantalizing incomplete stories revisit Austen's customary milieu of courtship and venture into new territory, amid guests at a seaside resort. Both are worth reading for pleasure and study. 112pp. 5⅜ x 8¼. 0-486-45793-1

THE SCARLET LETTER, Nathaniel Hawthorne. With stark power and emotional depth, Hawthorne's masterpiece explores sin, guilt, and redemption in a story of adultery in the early days of the Massachusetts Colony. 192pp. 5³⁄₁₆ x 8¼.
0-486-28048-9

THE SEASONS OF AMERICA PAST, Eric Sloane. Seventy-five illustrations depict cider mills and presses, sleds, pumps, stump-pulling equipment, plows, and other elements of America's rural heritage. A section of old recipes and household hints adds additional color. 160pp. 8⅜ x 11. 0-486-44220-9

SELECTED CANTERBURY TALES, Geoffrey Chaucer. Delightful collection includes the General Prologue plus three of the most popular tales: "The Knight's Tale," "The Miller's Prologue and Tale," and "The Wife of Bath's Prologue and Tale." In modern English. 144pp. 5³⁄₁₆ x 8¼. 0-486-28241-4

SELECTED POEMS, Emily Dickinson. Over 100 best-known, best-loved poems by one of America's foremost poets, reprinted from authoritative early editions. No comparable edition at this price. Index of first lines. 64pp. 5³⁄₁₆ x 8¼. 0-486-26466-1

SIDDHARTHA, Hermann Hesse. Classic novel that has inspired generations of seekers. Blending Eastern mysticism and psychoanalysis, Hesse presents a strikingly original view of man and culture and the arduous process of self-discovery, reconciliation, harmony, and peace. 112pp. 5³⁄₁₆ x 8¼. 0-486-40653-9

SKETCHING OUTDOORS, Leonard Richmond. This guide offers beginners step-by-step demonstrations of how to depict clouds, trees, buildings, and other outdoor sights. Explanations of a variety of techniques include shading and constructional drawing. 48pp. 11 x 8¼. 0-486-46922-0

Browse over 9,000 books at www.doverpublications.com

SMALL HOUSES OF THE FORTIES: With Illustrations and Floor Plans, Harold E. Group. 56 floor plans and elevations of houses that originally cost less than $15,000 to build. Recommended by financial institutions of the era, they range from Colonials to Cape Cods. 144pp. 8⅜ x 11. 0-486-45598-X

SOME CHINESE GHOSTS, Lafcadio Hearn. Rooted in ancient Chinese legends, these richly atmospheric supernatural tales are recounted by an expert in Oriental lore. Their originality, power, and literary charm will captivate readers of all ages. 96pp. 5⅜ x 8½. 0-486-46306-0

SONGS FOR THE OPEN ROAD: Poems of Travel and Adventure, Edited by The American Poetry & Literacy Project. More than 80 poems by 50 American and British masters celebrate real and metaphorical journeys. Poems by Whitman, Byron, Millay, Sandburg, Langston Hughes, Emily Dickinson, Robert Frost, Shelley, Tennyson, Yeats, many others. Note. 80pp. 5³⁄₁₆ x 8¼. 0-486-40646-6

SPOON RIVER ANTHOLOGY, Edgar Lee Masters. An American poetry classic, in which former citizens of a mythical midwestern town speak touchingly from the grave of the thwarted hopes and dreams of their lives. 144pp. 5³⁄₁₆ x 8¼.
0-486-27275-3

STAR LORE: Myths, Legends, and Facts, William Tyler Olcott. Captivating retellings of the origins and histories of ancient star groups include Pegasus, Ursa Major, Pleiades, signs of the zodiac, and other constellations. "Classic." — *Sky & Telescope.* 58 illustrations. 544pp. 5⅜ x 8½. 0-486-43581-4

THE STRANGE CASE OF DR. JEKYLL AND MR. HYDE, Robert Louis Stevenson. This intriguing novel, both fantasy thriller and moral allegory, depicts the struggle of two opposing personalities — one essentially good, the other evil — for the soul of one man. 64pp. 5³⁄₁₆ x 8¼. 0-486-26688-5

SURVIVAL HANDBOOK: The Official U.S. Army Guide, Department of the Army. This special edition of the Army field manual is geared toward civilians. An essential companion for campers and all lovers of the outdoors, it constitutes the most authoritative wilderness guide. 288pp. 5³⁄₁₆ x 8¼. 0-486-46184-X

A TALE OF TWO CITIES, Charles Dickens. Against the backdrop of the French Revolution, Dickens unfolds his masterpiece of drama, adventure, and romance about a man falsely accused of treason. Excitement and derring-do in the shadow of the guillotine. 304pp. 5³⁄₁₆ x 8¼. 0-486-40651-2

TEN PLAYS, Anton Chekhov. *The Sea Gull, Uncle Vanya, The Three Sisters, The Cherry Orchard,* and *Ivanov,* plus 5 one-act comedies: *The Anniversary, An Unwilling Martyr, The Wedding, The Bear,* and *The Proposal.* 336pp. 5³⁄₁₆ x 8¼. 0-486-46560-8

THE FLYING INN, G. K. Chesterton. Hilarious romp in which pub owner Humphrey Hump and friend take to the road in a donkey cart filled with rum and cheese, inveighing against Prohibition and other "oppressive forms of modernity." 320pp. 5⅜ x 8½. 0-486-41910-X

THIRTY YEARS THAT SHOOK PHYSICS: The Story of Quantum Theory, George Gamow. Lucid, accessible introduction to the influential theory of energy and matter features careful explanations of Dirac's anti-particles, Bohr's model of the atom, and much more. Numerous drawings. 1966 edition. 240pp. 5⅜ x 8½. 0-486-24895-X

TREASURE ISLAND, Robert Louis Stevenson. Classic adventure story of a perilous sea journey, a mutiny led by the infamous Long John Silver, and a lethal scramble for buried treasure — seen through the eyes of cabin boy Jim Hawkins. 160pp. 5³⁄₁₆ x 8¼.
0-486-27559-0

THE TRIAL, Franz Kafka. Translated by David Wyllie. From its gripping first sentence onward, this novel exemplifies the term "Kafkaesque." Its darkly humorous narrative recounts a bank clerk's entrapment in a bureaucratic maze, based on an undisclosed charge. 176pp. 5³⁄₁₆ x 8¼. 0-486-47061-X

THE TURN OF THE SCREW, Henry James. Gripping ghost story by great novelist depicts the sinister transformation of 2 innocent children into flagrant liars and hypocrites. An elegantly told tale of unspoken horror and psychological terror. 96pp. 5³⁄₁₆ x 8¼. 0-486-26684-2

UP FROM SLAVERY, Booker T. Washington. Washington (1856-1915) rose to become the most influential spokesman for African-Americans of his day. In this eloquently written book, he describes events in a remarkable life that began in bondage and culminated in worldwide recognition. 160pp. 5³⁄₁₆ x 8¼. 0-486-28738-6

VICTORIAN HOUSE DESIGNS IN AUTHENTIC FULL COLOR: 75 Plates from the "Scientific American – Architects and Builders Edition," 1885-1894, Edited by Blanche Cirker. Exquisitely detailed, exceptionally handsome designs for an enormous variety of attractive city dwellings, spacious suburban and country homes, charming "cottages" and other structures — all accompanied by perspective views and floor plans. 80pp. 9¼ x 12¼. 0-486-29438-2

VILLETTE, Charlotte Brontë. Acclaimed by Virginia Woolf as "Brontë's finest novel," this moving psychological study features a remarkably modern heroine who abandons her native England for a new life as a schoolteacher in Belgium. 480pp. 5³⁄₁₆ x 8¼. 0-486-45557-2

THE VOYAGE OUT, Virginia Woolf. A moving depiction of the thrills and confusion of youth, Woolf's acclaimed first novel traces a shipboard journey to South America for a captivating exploration of a woman's growing self-awareness. 288pp. 5³⁄₁₆ x 8¼. 0-486-45005-8

WALDEN; OR, LIFE IN THE WOODS, Henry David Thoreau. Accounts of Thoreau's daily life on the shores of Walden Pond outside Concord, Massachusetts, are interwoven with musings on the virtues of self-reliance and individual freedom, on society, government, and other topics. 224pp. 5³⁄₁₆ x 8¼. 0-486-28495-6

WILD PILGRIMAGE: A Novel in Woodcuts, Lynd Ward. Through startling engravings shaded in black and red, Ward wordlessly tells the story of a man trapped in an industrial world, struggling between the grim reality around him and the fantasies his imagination creates. 112pp. 6⅛ x 9¼. 0-486-46583-7

WILLY POGÁNY REDISCOVERED, Willy Pogány. Selected and Edited by Jeff A. Menges. More than 100 color and black-and-white Art Nouveau–style illustrations from fairy tales and adventure stories include scenes from Wagner's "Ring" cycle, *The Rime of the Ancient Mariner, Gulliver's Travels,* and *Faust.* 144pp. 8⅜ x 11. 0-486-47046-6

WOOLLY THOUGHTS: Unlock Your Creative Genius with Modular Knitting, Pat Ashforth and Steve Plummer. Here's the revolutionary way to knit — easy, fun, and foolproof! Beginners and experienced knitters need only master a single stitch to create their own designs with patchwork squares. More than 100 illustrations. 128pp. 6½ x 9¼. 0-486-46084-3

WUTHERING HEIGHTS, Emily Brontë. Somber tale of consuming passions and vengeance — played out amid the lonely English moors — recounts the turbulent and tempestuous love story of Cathy and Heathcliff. Poignant and compelling. 256pp. 5³⁄₁₆ x 8¼. 0-486-29256-8